3/88

D0931305

INDIAN MASKS
of CANADA

This Collector's Edition is limited to 500 copies of which this Volume is No. 191

The publisher wishes to thank the Ontario Arts Council for a grant in aid of publication.

INDIAN MASKS
of Canada

by Derek Crawley

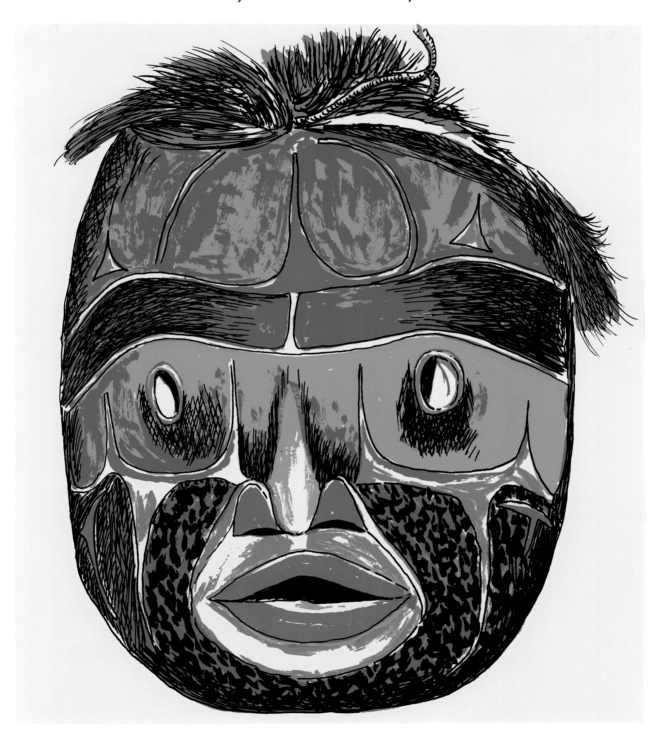

Silk Screening: Nick and Helma Mika

Fifty Indian Masks located in various museums throughout Canada were sketched by Nick and Helma Mika and were hand-printed by one of the oldest methods of reproduction, the *silk screening process*.

Indian Masks of Canada
Copyright © Mika Publishing Company, 1982

ISBN 0-919303-49-8
Printed and bound in Canada

Foreword

During the summer of 1967, the year Canada celebrated one hundred years of Confederation, my wife and I went to Ottawa on several occasions to visit the Parliament Buildings, the Public Archives, and a number of museums. On one of these visits we enjoyed a display of Indian masks and were fascinated not only by their beauty, but also by the legends that surround them.

Our next step was a visit to Toronto and the Royal Ontario Museum, where I began sketching some of the Indian masks with the thought of producing a book on this subject.

Our most rewarding journey in this connection, however, was a motor trip across Canada from eastern Ontario to Victoria, British Columbia, which included stops at every major museum along the way. There we discovered a great deal of Canada's past.

Winnipeg, with its magnificent new Museum and Art Gallery and the sincere hospitality of its people caused us to stay much longer than we had planned. Thank you, Winnipeg, for a wonderful time.

In Calgary we visited the Glenbow Alberta Institute where I spent a few days sketching the Indian masks on display there. From the Vancouver Centennial Museum, where we received valuable assistance, we went to the Victoria Provincial Museum, a most enchanting and fascinating place. Its collection of totem poles, Indian masks, carvings and other artifacts makes it one of the most unique museums, not only in British Columbia, but also in all of Canada. Our only regret was that we could not stay longer to absorb the spiritual meaning that inspired these masterpieces created by the native people of this province and left to us as a precious legacy.

Our trip to the west was educational and conveyed some idea of the magnitude and beauty of this land and how rich in its resources and its people Canada is. It made us proud to be Canadian. Not that we were in search of an identity. That we had already found, but we were able to glimpse into the history of a great nation.

We would like to thank Professor Derek F. Crawley who took time from his busy teaching schedule at Queen's University in Kingston, to do extensive research and give a description of the Canadian Indian masks depicted on the pages of this book.

Nick and Helma Mika

Introduction

It is to be hoped that the purchaser of this volume will realize what a treasure he or she possesses. All pictures are from Mr. Mika's hand-painted reproductions using the laborious and exacting serigraph (silk-screening) process. Each separate colour has required a reprocessing of each page. The work done by the Mika Publishing Company took one full year to complete.

Mr. Mika did not want this volume to have too "learned" an approach, so I have tried to be selective in the material presented. He also wanted the aesthetic appeal of the individual masks to speak directly to the viewer; I hope that my occasional comments will not detract from this objective.

In my search for information about some of the masks, I went to see Mr. Dennis Alsford and his staff at the National Museum of Man in Ottawa. Because I had no direct means of connecting the various masks with the reproductions, I did not expect the staff to be able to identify very many of them at the Museum. Within three hours, however, John Baker, the Collections Manager, Judy Hall, the Cataloguer, Glen Forrester, a Collections Assistant, and Barbara Winter, who works on the computer program, had located almost all the masks in this volume held by the National Museum of Man, and I was able to study them. It is a tribute to Mr. Mika's precise art that the masks were as easily identified as they were, and a tribute to Mr. Alsford's staff that they found their way around that vast collection with such ease.

I would also like to thank Mr. Kenneth R. Lister of the Department of Ethnology, Royal Ontario Museum, for information which he sent me. I am likewise grateful to Ms. M.A. Chechik, Collections

Technician in the Ethnology Division at the British Columbia Provincial Museum in Victoria for information on masks depicted in Plates 9 and 10. For his invaluable help and support, I am greatly indebted to William F.E. Morley, Curator of Special Collections at Queen's University.

I am indebted also to Mrs. Lynn Maranda, curator of Ethnology at the Vancouver Centennial Museum for the information that she kindly provided for masks represented in Plates 11, 12 and 28.

Mr. and Mrs. Mika and I would like to thank the Ontario Arts Council for financial support in the preparation of this volume.

Note: Captions which are followed by an asterisk were kindly supplied by the publisher.

<div align="right">Derek F. Crawley</div>

CONTENTS

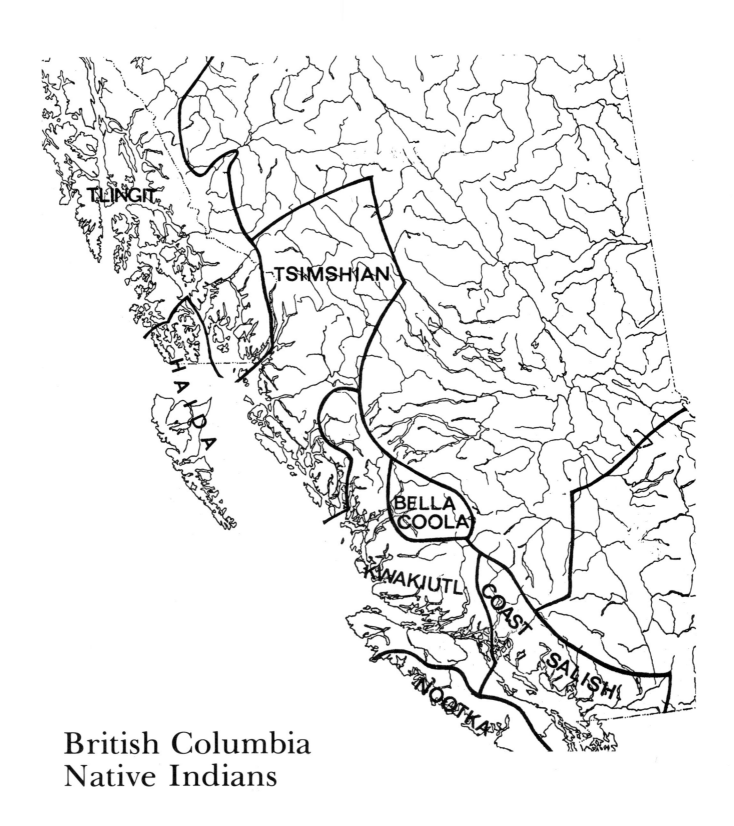

TLINGIT

HAIDA

TSIMSHIAN

BELLA COOLA

KWAKIUTL

COAST SALISH

NOOTKA

British Columbia
Native Indians

NORTHWEST COAST INDIANS

Use of Masks

There is evidence to show that masks were used by the Northwest Coast Indians of what is now British Columbia on many occasions and for many purposes. They were sometimes seen as a manifestation of the spirits found in natural objects and in animals; as a representation of an initiate's acceptance into, and qualification for, membership in a secret society; as proof that this young man was possessed by a spirit[1]; as part of a shaman's (medicine man's) ceremonial dance to cure the sick; as an heirloom which indicated family prestige and social rank on an occasion of public celebration or festivity (usually in the spring or winter); as part of the ceremony to propitiate the spirits for food, weather, or good hunting; as objects of horror that impressed the beholders with the power of the spirits.

A use that few commentators mention is one observed by Captain James Cook in March, 1778 when he first contacted Nootka Indians on the east coast of Vancouver Island. The mask was used as part of a ceremonial introduction and greeting from an Indian of rank:

> A considerable number of the Natives visited us daily and we every now and then saw new faces. On their first coming they generally went through a singular ceremony; they would paddle with all their strength quite round both Ships, A Chief or other principal person standing up with a Spear, or some other Weapon in his hand and speaking, or rather holloaing all the time, sometimes this person would have his face cover[ed] with a mask, either that of a human face or some animal, and some times instead of a weapon would hold in his hand a rattle.[2]

With his usual thoroughness of observation, Cook tells us how the "savage and incongruous appearance" of the natives is

> much heightened when they assume, what may be called, their monstrous decorations. These consist of an endless variety of carved wooden masks or vizors, applied on the face, or to the upper part of the head or forehead. Some of these resemble human faces, furnished with hair, beards, and eye-brows; others, the heads of birds, particularly of eagles and quebrantahuessos; and many, the heads of land and sea-animals, such as wolves, deer, and porpoises, and others. But, in general, these representations much exceed the natural size; and they are painted, and often strewed with pieces of the foliaceous *mica*, which makes them glitter, and serves to augment their enormous deformity. They even exceed this sometimes, and fix on the same part of the head large pieces of carved work, resembling the prow of a canoe, painted in the same manner, and projecting to a considerable distance. So fond are they of these disguises, that I have seen one of them put his head into a tin kettle he had got from us, for want of another sort of mask.[3]

Cook and his crew speculated on possible uses of these masks:

> Whether they use these extravagant masquerade ornaments on any particular religious occasion, or diversion; or whether they be put on to intimidate their enemies when they go to battle, by their monstrous appearance; or as decoys when they go to hunt animals, is uncertain.[4]

Preserved in the British Museum and elsewhere are eleven masks that the Cook expedition brought back from Nootka Sound.[5] They depict human faces, wolves' heads, an eagle's head and include a forehead mask. From the beginning of contact with Indian culture, white men regarded the masks as *objets d'art*.

Indian Tribes

The masks in this volume which come from the Indian Tribes of the Northwest Coast of British Columbia represent the work of five tribes. Beginning with the most northerly, they are the Haida, the Tsimshian, the Bella Coola, the Kwakiutl and the Nootka. The Bella Bella (represented by plates 34 and 39) are simply a sub-tribe of the Kwakiutl; their aggressiveness made Alexander Mackenzie turn back in 1793. Later, they were almost wiped out by disease.

Because Indian masks so often carry the human countenance, a short and non-technical note on the physical anthropology is in order. Although measurements were not taken until contact with white men had been going on for about one hundred years, there are enough differences discernible between two groupings of the Northwest tribes to be of considerable interest.

Basically, the Indians of North America are of the Mongoloid type and the different physical types are always variants thereof. The northern tribes such as the Haida and Tsimshian are taller (average of 169 cm.) than the tribes of the south and have longer legs and arms and relatively shorter bodies. They also have rather large and broad heads and faces. The usual nose among these tribes is concave.

By comparison the Bella Coola, the southern Kwakiutl and Nootka are a people of more medium height (162 to 166 cm.) and of much different body type. They tend to be long bodied and to have comparatively short arms and legs; they also have broad shoulders and deep chests. The main facial differences include large and broad jaws (plates 25 and 43), longish faces (plate 28), and great length of nose that is usually narrow and remarkably convex (plates 24, 36 and especially 38).

The Haida ("People")

In 1774 a Spaniard named Juan Josef Pérez Hernandez was the first European to make contact with the Haida Indians. He saw them at Langara (North) Island in the Queen Charlotte Islands. Because word had reached the Spaniards that the Russians were exploring Alaska, Pérez was sent to investigate whether there was a threat to the Northern Boundary of "Alta California". As in the case of Cook four years later when he was first sighted by the Nootkas, Pérez was greeted by canoes in which a man danced, wore a mask and threw feathers into the water (a symbol of peace). Although items of Indian craft were collected, they have never found their way into museums.

Primarily a people of the ocean, the Haida fed on salmon and halibut and utilized sea-otters and fur seals for clothing. The only animals of the woods they seemed to kill were the black bears when they came to the shores in search of fish. They conducted widespread raids on the other tribes of the Northwest coast. This led them to imitate the basket-weaving skills of the Tlingit as well as their tribal and family organization. From the Tsimshian they took many of their dances, songs and even the idea of secret societies whose ceremonies featured masks so prominently. When these secret societies started forming, the Haida chiefs prevented the initiates from taking over authority in community affairs during the period of ritual. This is what had happened among the Kwakiutl who first initiated secret societies in the area.

As with the other northwest coastal tribes, the medicine men of the Haida were thought to have acquired special powers through contact with spirits shown on their curing masks. Methods of treating the sick included the use of herbal remedies, massaging, sucking on affected areas through carved bone-tubes, and engaging in curing dances. Like the Tsimshian, the shaman of the Haida used the strange "soul catcher" to

pick up the escaping soul of the sick person and put it back into the body.

Something that the Haida shared with other northwest tribes was the institution of the potlach, a feast and entertainment which involved the giving of gifts and the demonstration of family social standing through the display of wealth and possessions (including masks). Any major family occasion such as a birth or marriage in a chief's family could result in one of these grand celebrations that was accompanied by songs, dancing, and little dramas. When the gifts—which might include furs, carved objects, canoes and woven clothing—were handed out with ceremonial politeness, there was a strict observance of the social rank of the recipient. The man of highest rank received his gift first. The term "Indian giver" undoubtedly relates to the fact that at these potlaches, a very strict account was kept of gifts given because they imposed an obligation of return with interest upon those honoured. Where the heads of Kwakiutl clans were involved, a gift was expected to be returned with 100% interest; for instance, if a Head gave twenty furs at one potlach, he would expect forty back at the next. If the receiver failed to live up to this obligation, he would, in effect, be acknowledging an inferior status and so would be disgraced. Only a defeat in battle would be seen as an equivalent humiliation. It is little wonder that potlaches were later banned in the province.

Because enough food could, with little difficulty, be secured during the summer, the winter was free for enjoyment and the potlaches were usually held at that time. If a man wished to inherit a high social position, it was essential that a potlach be given for him by his father or his uncle. By the giving of gifts, his new title was not only publicly acknowledged but it gave him a right to sing special songs and recount myths.

From the journal of Jacinto Caamaño, an observant Spanish explorer who visited the Queen Charlotte Islands at the end of the 18th century, we have very

interesting details about the use of masks during an entertainment that Indian friends insisted on giving him:

> Jammisit [the Chief] came to visit me in the afternoon, accompanied by upwards of forty of his relatives, all singing and bringing feathers. He, together with his nearest relations, arrived in one of two canoes lashed alongside each other. Jammisit's head appeared from behind a screen formed of brilliantly white deerskin; on it, accordingly as the action demanded or his own particular fancy dictated, he would place various masks or heads of the different animals that he proposed to imitate; the deerskin serving as a curtain by which he was entirely hidden when he wished, unseen to put on or change one of these masks or faces. They remained alongside thus for sometime, singing and continuing their antics, until Jammisit with great eagerness explained that he was come to conduct me to his village.

The village was across the water and the Indians in their speedy canoes raced ahead of Caamaño so as to give him a special welcome on his arrival. When Caamaño reached the shallows, six muscular Indians were waiting to carry him in a deerskin to the village. Rather apprehensively the Spaniard agreed and was carried swiftly to the village and through the doorway of a chief's house over which "was painted a huge mask". He was installed in a seat on the same level as the chief opposite, upon whose new mantle "were painted various grotesque masks or faces". After formal greetings from the chief who came over, sat at Caamaño's feet and blew feathers on the guest, Jammisit's entertainment began. The passage is worth quoting at length:

> On his head was a large well-imitated representation of a sea-gull's head, made of wood and coloured blue and pink, with eyes fashioned out of polished tin; while from behind his back stuck out a wooden frame covered in blue cloth, and decked out with quantities of eagles' feathers and bits of whale bone, to complete the representation of the bird.[6] His cloak was now of white

calico, bearing a blue flowered pattern, trimmed with a brown edging. Round his waist hung a deer skin apron falling to below the knee . . . On his legs were deerskin leggings, tied behind with four laces, ornamented with painted masks and trimmed with strips of hide carrying claws. Clad in this weird rattling rig, he then began to leap and cut capers, reminding one of a rope-dancer trying his rope. He also waved his arms, keeping them low down . . . After two or three preliminary attempts, he started a song. This was at once taken up by every one inside the house, man or woman, and produced a terrific volume of sound, to whose measure he then began to dance, while a specially chosen Indian beat the time on a large drum. . . .

The old chief having recovered from his exhaustion due more to his age than the exercise, and being now dressed in the costume for his next performance, the curtain was drawn, and he appeared with a half-length wooden doll on his head.[7]

Two Indians at some distance behind him, who endeavoured to conceal their actions, then proceeded— by means of long fishing rods—to open and close the eyes of the doll, and raise its hands, in time to another tune that was struck up, while the dancer himself imitated the movements of the doll's face, which was sufficiently frightful in appearance, being coloured black and red, and furnished with an owl's beak and nostrils. For this scene, he wore a bear skin cloak, with the remainder of his costume as before. So soon as the music ceased, his attendants again hid him from sight. Before long, however, he again appeared, this time wearing a heavy wooden mask on his head, of which the snout, or upper jaw, was moveable.[8] He also carried a blue cloth mantle, such as distinguishes the chiefs, and the timbrel (or 'jingles') . . . He began by making various weird move-ments, on which a new tune was started when his gestures and contortions soon worked him into such a state of frenzy, that he reached the point of fainting, and would doubtless have collapsed, had not the attendants quickly come to his aid. . . . These attentions soon revived him, though groaning heavily. He was then led to his seat, his mask and mantle taken off, and the latter exchanged for the one he had earlier worn. He then presented me with a nutria skin and returned to his place, when all the rest of the Indians rose up from theirs. I thereupon did the same, which being seen by my native escort, they at once got ready my coach (the large deer skin as a litter), put me into it, and quickly carried me down to my boat.[9]

This is a most detailed and informative description of ceremonial entertainment involving the use of masks.

Tsimshian

The Tsimshian lived on the lower regions of the Nass and Skeena Rivers. With the establishment of a Hudson's Bay Company post first at the mouth of the Nass River (1831) and then at the mouth of the Skeena, the Tsimshian had direct and continuous contact with European trade. Their fame lay in their carving of totem poles, masks and rattles. As is generally true on the Northwest Coast, the traders arrived before the missionaries: in the case of the Tsimshian, Dr. John McLaughlin, the factor of Hudson's Bay, before William Duncan, a missionary with the Church of England. As a result, the native art was encouraged and flowered with the demand for artifacts before any zealous priest could try to stamp out anything (such as masks) associated with pagan religious ceremonies. And the Tsimshian were quick to recognize the advantages of trade. With their location on the mouth of the Nass River, they were in the best position to control the supply of oil from the candle-fish, a product much relished by inland tribes. Situated as they were with the Haida in front of them, the copper-trading Tlingit on the north and the Kwakiutl on the south, they acted as the prosperous middlemen.

Interesting insights into Tsimshian cultural artifacts such as masks, totem poles, and crests can be gained by looking at representative tribal myths. These folktales often tell how a certain motif or image, for example a hawk with a sharp beak, came into their art; such a myth is "The Sharp Nosed One"[10] which might well have relevance to plate 14, but more likely to a mask such as that in Plate 20.

In this folktale the children who are not old enough to take part in the winter potlach are making so much noise that they disturb a sleepy Sky Chief. The Sky Chief orders a slave to go to the lower world and warn the children to be quiet; but because it is only a slave who comes to rebuke them, the children take no notice.

Angry, the Sky Chief orders several of his slaves to go and bring them to him. When the slaves arrive on earth, the children have grown tired and are asleep. Without waking them, the slaves take them to the realm of the Sky Chief. When the first child awakens, his screams rouse all the others. A slave takes one of the boys before the Sky Chief who orders him placed in front of the totem pole. On this pole is a hawk with a huge, sharp beak and suddenly the beak slices downwards and cuts the boy in half.

All the other screaming children are taken one by one to the totem pole and suffer the same fate. All, that is, except for one calm and dignified Princess who has not made any noise. When, at last, the slave comes to take her to the totem pole, she proudly says she will get properly dressed before she goes, and keeps the slave waiting. At last she appears dressed in sea-otter skins.

When she is put in front of the totem pole and the beak slashes downward, it only slices through her sea-otter cape and smashes itself to pieces on the ground.

The Sky Chief comes out to see what has happened and when he sees the Princess unharmed he says, "You are a brave girl and I will marry you to my son." In her usual proud way, the Princess says she would only do so if he were of royal blood and if she loves him. When the young man appears, they both fall quickly in love and are married by a shaman.

After a child is born, the Princess wants to return with her husband and baby to her tribe and is given permission by the Sky Chief to go. Transported to the front of her uncle's tent, she is not recognized by him because, unknown to her, much time has passed. When she sings a family song, she immediately becomes known and her uncle gives a potlach at which he declares the Sky Chief's son the new prince and chief of the tribe. The family emblem and masks from that time on will depict the sharp-nosed hawk.

This myth reveals several important aspects of Tsim-

shian tribal life and values. One is the rigidity of the class system and the behaviour expected of slaves and princesses. Before she will agree to marry, the Princess has to be assured of the rank of her future husband. Important families not only had their own recognizable songs, but declared a potlach to celebrate a significant family event. The magic totem pole and the hawk face show how distinctive elements of Indian art are easily incorporated in mythological story. Not only does the hawk's head and sharp beak become the emblem of the new chief in the folktale, but we can see how it would also be placed on the family masks used at entertainments and feasts, and on the totem pole as well. It symbolizes family descent and tribal tradition. As in other religions and myths, god's (here the Sky Chief's) son manifests himself to earthlings, lives among them and becomes their king of kings or chief.

Another myth entitled "Crest From the Ocean"[11] tells how the killer whale was introduced into the art of the Tsimshian.

A fisherman who had caught nothing for three days pulled up his stone anchor and begged that good luck be his at the next location. When he got near the coast where a mountain went straight down into the water, he tossed out his anchor and it plunged down onto the roof of a killer whale's house. Curious to know what caused all the noise, the whale swam out and saw the stone and the anchor rope. With a strong pull he brought down into his house the fisherman, the boat and all!

Although the fisherman was at first fearful for his safety and thought he might be made a slave, he soon found that his host wanted nothing more than to teach him how to draw and paint killer whales on masks, totem poles and crests. Over many moons he was also taught songs and dances that celebrated the killer whale.

When, at last, the fisherman knew everything he had been taught, the killer whale put him back in his boat and returned him to the surface of the ocean. Although he thought he had only been away for one moon, the fisherman realized that much time had passed when he

saw the dilapidated condition of his house. He immediately built another one and, utilizing his new skills, painted a picture of a killer whale on it and on a dancing mask. He then invited all the people from the village and surprised them with his new songs.

The importance of the fisherman, the sea, and sea creatures to this tribe is evident in this little tale; and again we see the way art and everyday life are integrated.

Kwakiutl ("Beach on the other side of the river")

In winter the Kwakiutl thought that spirits and nature came more closely together and the Invisible were walking the earth. It was then that the secret societies re-enacted their encounters with the spirit world in elaborately staged performances. The initiated were the actors and the uninitiated the spectators. With the coming of Fall, family members wore masks of remembrance for those who had died since the last winter ceremonial. After that came a period of light-hearted celebration that followed the work of the spring and summer. Dancers were everywhere and family masks were displayed as part of the family's possessions. After the appearance of a masked figure named Gakhula, there was both ritual bathing and sounds from the woods that told of the presence of invisible spirits.

In discussing Kwakiutl potlaches and ceremonies honouring the erection of totem poles or the building of houses, Boas tells us that masks were often used. Still another occasion was the public declaration by the chief of his heir presumptive. A mask was produced to depict a forefather of the chief and the legend associated with him. During such a ceremony, property was either destroyed (reflecting the angry part of the mask) or distributed as an honour to the successor or as a means of self-aggrandizement by the chief. In earlier days the destruction of property would involve the killing of a slave; later on, the slave was given as a present.

The secret societies of the Kwakiutl were the entertainers of the tribe with the Shamans performing in early winter and Those Who Descend from the Heavens performing in the early spring season. In both cases their shows had seemingly magical qualities and ranged from the serious to the comic in tone. Where the Shaman tended to be violent and aggressive in behaviour—and their masks sometimes depicted monsters—Those Who Descend from Heaven wore masks of the more gentle spirits of heaven and the sea. Within the Shaman's Society the highest ranking performer was Cannibal who seemingly ate a victim on stage. The gory effect was aided by having a bladder full of blood burst at the appropriate moment. The next ranking actors in this society were known as Grizzly Bear and Warrior who during the performance raced around destroying property. Behind all these actions was supposedly the re-enactment of the process by which the Society acquired its supernatural powers. And the performances always included masks, songs, dances and the taking of new names different from the work-a-day ones of spring and summer. The myth behind most Kwakiutl entertainments is the ancestor who came either from the sky, the sea or the underground disguised in the form of, and in the mask of, an animal. When he came to the specific location of the Kwakiutl homeland, he removed his mask and became a man.

Hays writes that "the three themes of death and resurrection, kidnapping by supernatural forces, and demonic possession are central to all Northwest drama."[12] We can see all three themes in a Kwakiutl custom at entertainments. If a dancer did not execute the required dance steps properly, he was "killed" by the higher ranking dancers; a few days later he would miraculously reappear in another performance. Because the secret societies were most highly developed among the Kwakiutl, Boas feels that the violence in theatrical performances came originally from that tribe and from there spread to other Northwest Coast tribes.

Nootka

Plate 30 is a stylized representation of the wolf which the Nootka took as their special animal. Normally seen on the Northwest Coast as the guardian spirit of warriors, the wolf had a particular importance for the Nootka because of a myth that told of an ancestor who had spent four days with the wolf spirits and had learnt from them special songs and dances. When he returned to his tribe, the ancestor was surprised to find that his actual time of absence had been four years, not four days.

Winter ceremonials among the Nootka placed more emphasis upon the wolf myth than on any other; there was a complete cycle of action that traditionally went along with the re-enactment of the story. The approach of the wolf spirits was heralded by noises in the woods (usually created by wooden horns), and thereafter men dressed in wolf-skins and masks—and running around on all fours— would appear in the village and kidnap a number of boys who became the latest initiates. These novices were taken away for four days and taught the songs and dances brought back long ago by the ancestor. While this was going on, the villagers celebrated in a festive and unrestrained manner and were entertained by fools and clownish dancers. Parents whose children had been kidnapped were teased and criticized for being inattentive parents and were tossed into the sea as punishment. Because the word "wolf" was tabu, villagers had great sport in trying to trap neighbours into saying the forbidden word. When several days had gone by, the sound of horns once again came from the woods and the "wolf" pack appeared on a shore or beach across the river. Tying several canoes together with planks across the gunwales, the villagers went to rescue their youngsters. Mock attacks, four in number, on the wolves and the wolves on the villagers resulted in the "wolf" pack being driven off and the seemingly reluctant boys—who had had their faces painted—brought

back across the water. These initiates, dressed in cedar and hemlock cloaks and kilts, had been given emblems that showed they had been initiated and enjoyed special privileges. The emblems of those of high social rank might be a largish crest carried by an attendant; those of lower rank were often headbands of shredded cedar bark. Because they were now supposedly possessed by the wolf spirits, the youngsters would sometimes perform some destructive acts such as breaking dishes and upsetting food pots. To be cleansed they had to be ritually bathed or washed and had to be walked around the village each day.

In time, the initiates demonstrated what they had learned from the wolves: this could be a special dance, a hereditary song, the display of a crest or mask, or the announcement of the special name they had been given. A potlach marked the end of these rituals and the cedar and hemlock branches the youngsters wore on their return from the wolves were burnt.

Menzies' Journal, which tells us a great deal about Vancouver's explorations in the 1790's, records a Nootka performance which indicates that even with the early contact with Europeans, the Indians were adapting their celebrations and dramas. In other words the love of the traditions did not prevent them from writing and enacting new performances:

> During this time a number of the Natives were equipping themselves in the adjacent houses, and now assembled at the Chief's door in a group of the most grotesque figures that can possibly be imagined, dressed, armed and masked in imitation of various characters of different Countries, some represented Europeans armed with Muskets and Bayonets, others were dressed as Chinese and others as Sandwich Islanders armed with Club and Spears; the rest were equipped either as Warriors or Hunters of their own nation. After a party of them armed with long spears entered and were drawn up at the further end of the House, the Actors came in one at a time and traversed the Area before us, with the most antic gestures. If a Warrior he showed the different evolutions of attacking an enemy, sometimes crouching down, sometimes retreating, at other times advancing with firm steps and eyes steadily fixed on the Camman-

ders who were seated in the middle of our group, and to whom all their feigned aims and motions were directed, sometimes with much pointed archness as to occasion some alarm of their intentions being real. The Hunters equipped with various masks and implements, shewd all the wiles and stratagems usual in taking or chasing different Animals as Deer, Bears, etc. While those armed with Muskets represented Sentinels or went through various motions of the manual exercise. And those representing the Sandwich Islanders traversed the Area in the different attitudes of wielding their Clubs or darting their Spears, and as each finished his part he retreated back and took his station among the masked group at the further end of the house.[13]

From our point of view, the most interesting feature of this description is the constant utilization of the masks during the performance even though the subject is anything but a traditional one.

Bella Coola

It is appropriate that a Bella Coola mask is the title-page illustration of this book. There is something arrestingly different about this tribe's work which one commentator dubs "rustic solidity."[14] If we glance at plate 40, there is indeed a sense of "bulging solidity" and "the colours tend to be dense and somewhat hot"; and certainly the nose in plate 38 is "emphasized to the verge of caricature." This would be even more obvious if the profile could be shown. Whether the less strict observance of class distinction among the Bella Coola (than, say, among the Tsimshian) is translated into a "less patrician art" is perhaps more doubtful. The Bella Coola were less concerned about places of rank at potlaches and feasts than the Tsimshian—who would begin a feud if seating arrangements violated social gradation—but the Bella Coola myth of Alkuntam indicates that they saw themselves as their god's chosen people. Alkuntam was the creator of men and animals and he sent to earth forty-five founding families, each of whom established a village in the Bella Coola territory. On earth, the new settlers emerged from

animal skins which were sent back to the sky world. As a memento of their origin, however, these ancestors depicted these cloaks on their family crests. This direct contact with the realm in the sky can also be seen in their interpretation of the autumn ceremonies of the secret societies. Because they believed that all the spirits of this world returned at the beginning of each winter to perform before the sky god, their own secret-society performances were imitations of these ceremonies and were overseen and blessed by the supernatural spirits. With the uninitiated, this gave an air of awe and mystery to the performances in the houses. With this intimate contact with the other-world, the Bella Coola probably felt that the artificial distinctions of closely graded rank as established by man was not all that important!

One of the "dramatic performances" of the Bella Coola that included the use of masks was the celebration of the miracle of rebirth in spring. In this stage presentation, masked young people represented trees and bushes that could be found in that area and a vigorous young man represented the doctor who repelled the death-dealing force of the wind from the north. The wooden figure on stage was none other than Mother Nature who, during the play, gave birth to willow, gooseberry, nettle, grass, etc. Each of these shrubs would do a little dance on stage before leaving.[15]

The first white man whom the Bella Coola saw was Sir Alexander Mackenzie. After going down the Fraser River a short distance, he went overland through the territory of this friendly tribe and came out at the mouth of the Bella Coola in one of their borrowed canoes. This was in 1793. At that time the tribe may have numbered between two and three thousand and lived in about forty villages on the Dean and Bella Coola Rivers and on Dean Channel and North Bentinck Arm. Today, they number about three hundred and live in one village at the mouth of the river that bears their tribal name.

EASTERN WOODLAND INDIANS

Iroquois

Always strong allies of the British, the Iroquois—occupying roughly New York State and Southern Ontario—fought beside them during the American Revolution and, under Joseph Brant, moved from New York to Upper Canada when the war was over. They comprise Five Nations—the Mohawk, Oneida, Onandaga, Cayuga, and Seneca—and have settled in five reserves near Cornwall, Gibson, Tyendinaga, Six Nations and Oneida.

When Europeans first contacted the Iroquois in the seventeenth century, the False Face Societies were already strongly established; in spite of the attempts by missionaries and by the followers of Handsome Lake (who tried to wipe out the False Face Societies by branding their members as witches and evil beings), they continued to exist into this century.

Religious observances permeated the lives of the Iroquois, and the tribes identified spirits not only in the "Three Sisters" (corn, beans and squash) but in the thunder, wind and waterfall. For five days near the New Year, a general purification ceremony took place. After the "Keepers of the Faith" had made their own confessions while holding a belt of wampum, everyone in the tribe did the same. Next, the mind was cleansed through an examination of dreams. A Keeper of the Faith visited every household and, since the Iroquois were a matrilineal society, asked the matron of each dwelling what dreams her family had experienced. Meanwhile, the "False Faces" cleansed each dwelling on

their visits.

At the spring and fall festivals and when illness struck the tribe, members of the False-Face Society—accompanied on occasion by members of the Husk-Face Society [see plate 50]—donned masks that showed the spirits whose powers they summoned or possessed. The variety of these spirits can be seen in some of the masks reproduced in this volume: smiling or pleasant face, plate 45; straight lipped, plate 46; protruding tongue, plate 47; crooked mouth (representing the Great-World-Rim Being), plate 49. The Husk Face Society sometimes acted as harbingers for the better-known members of the Society of Faces. Appearing among Senecan Longhouses during two nights of the winter festival, the Husk Faces were supposedly farmers from the far side of the world.

The horrendous masks of the Society of Faces (or the False-Face Society) represent the spirits of evil, ill health and destruction which could be appeased or propitiated by gifts of such items as tobacco and mush. The rituals were believed to be an absolute necessity for the well-being of both tribe and individual. Specifically, the False Faces were powerful influences over winds, witches, bad luck and diseases associated with particular parts of the body (e.g. joints and head) and over sore eyes, toothaches and facial swellings.

Often through dreams the Faces communicated with individuals and indicated what sacrifice or gift they desired. When requests were met, the Faces taught their benefactors songs, and, as part of the treatment for patients who were sick physically and psychologically, the blowing or scattering of hot ashes and the laying of hands. Some favoured Iroquois were shown in their dreams how to carve masks of the Faces.

Though to us the Indian masks in this volume are primarily art objects, it is apparent that our appreciation can be enriched if we take the trouble to study some of the cultural and tribal traditions that lie behind them.

HAIDA

Plate 1

This beautifully carved face has holes cut out for eyes and nostrils and is bounded around the outside by a flaring border painted in bands of red, green and black. These bands completely encircle the face.

This mask appeared in the Crawley Films production, 1948, of the Indian myth entitled "The Loon's Necklace."

This mask was collected in 1879 by I.W. Powell in the Queen Charlotte Islands, British Columbia.

It is made of wood and measures 12″ by 13″ by 6″.

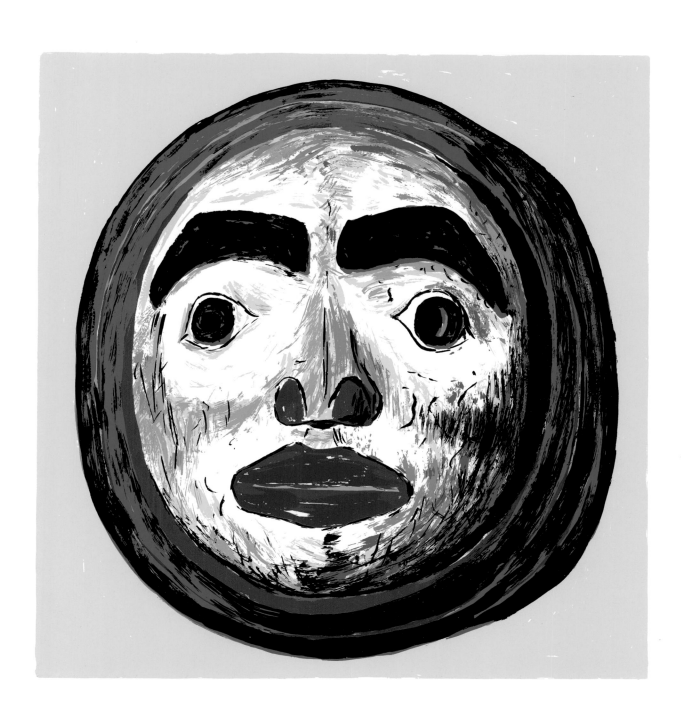

Plate 2

* Members of the Haida tribes wore this bearded mask in ceremonial dances. The mask is painted in blue, green and black colours. Nostrils and lips are red, and holes are cut out for the eyes and the nostrils. Made from wood, the mask is trimmed with horsehair.

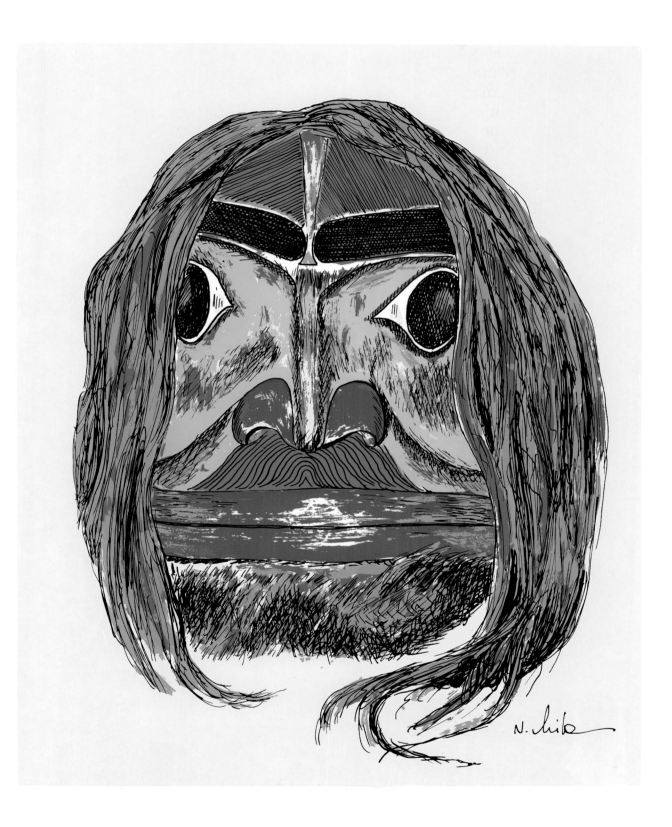

Plate 3

As in the case of Plate 1, this mask was collected in the Queen Charlotte Islands in 1879 by I.W. Powell. Like Plate I this mask appeared in the Crawley Film production of "The Loon's Necklace." It was "The Chief".

The three tufts are made of cedar bark and there is knotted rope in the area between the nostrils. Made of wood, the mask is 10½ inches in length and 8'' wide.

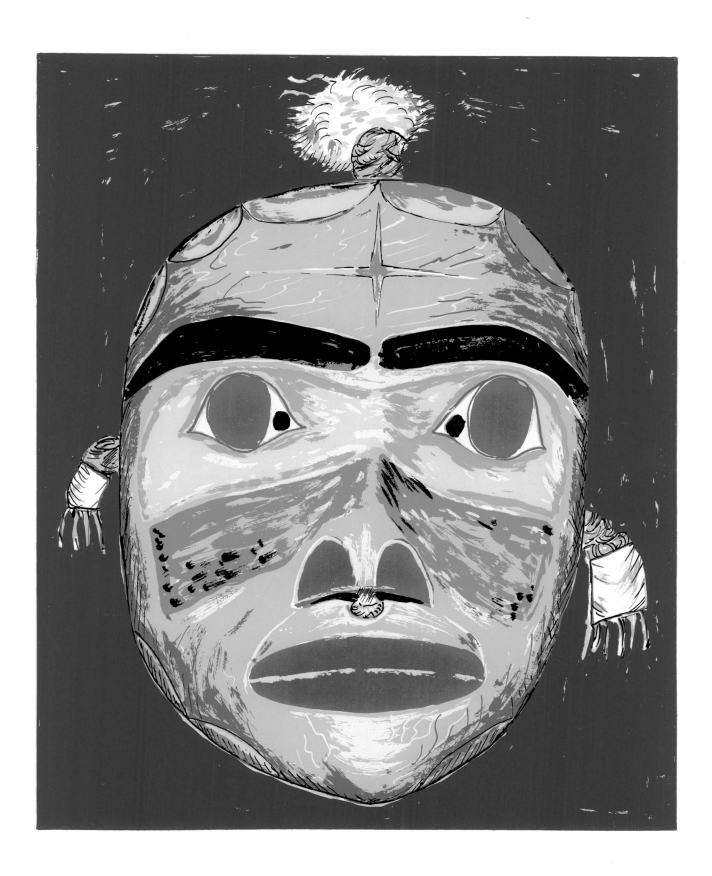

Plate 4

This mask comes from the Queen Charlotte Islands and was collected in 1884 by MacKenzie-Tolmie. In "The Loon's Necklace" this mask was "a villager".

This broad-cheeked wooden mask has the eye and nose area painted with blue dashes and the same colour is used for the moustache and for the two part beard. There is red paint on the lips and nostrils and a dash of red on the cheeks. The eyebrows and forehead and cheek designs are in black.

The broad-cheeked effect comes from the fact that both the height and width of this mask are 11".

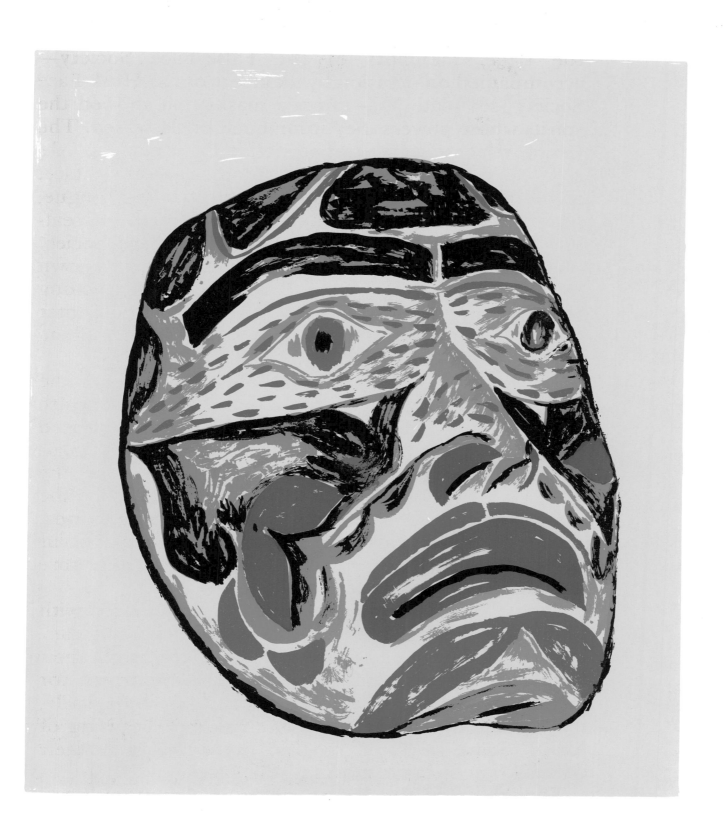

Plate 5

This Haida mask comes from the Queen Charlotte Islands and was collected by I.W. Powell in 1879.

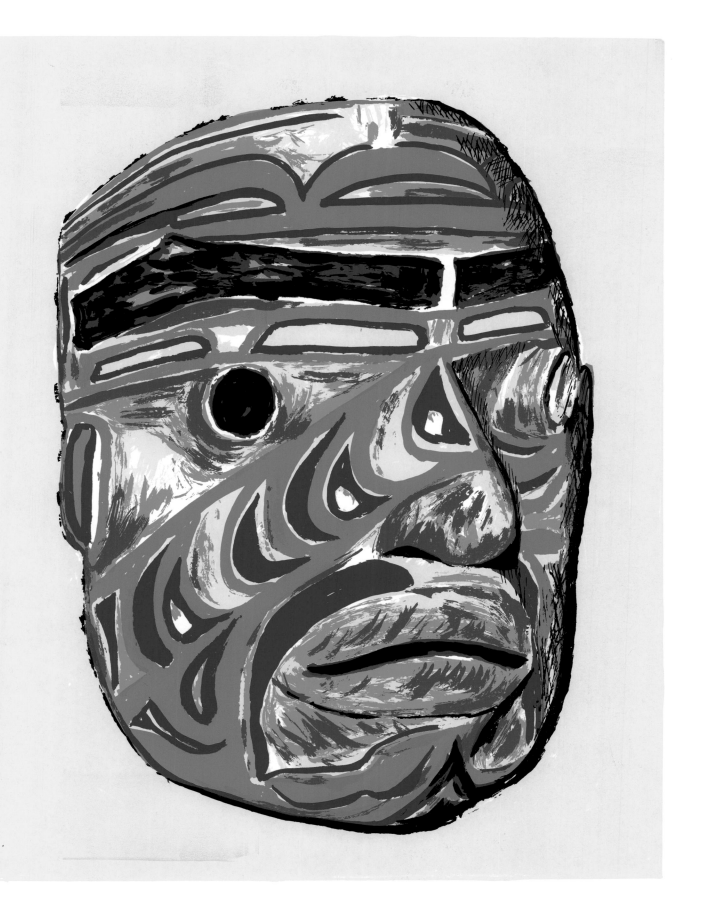

Plate 6

Because this mask of a woman is facing us, it is impossible to see the largish abalone ornament (labret) which makes the lower lip protrude markedly. The National Museum of Man has several of these labrets in its collection.

The three holes in the edge of each ear are threaded with red woollen strips, and from these strips hang abalone rectangles. In the forehead and cheeks there are many carved wrinkles.

In 1884 MacKenzie-Tolmie collected this mask at Massett. It is 9½'' by 7'' by 4''.

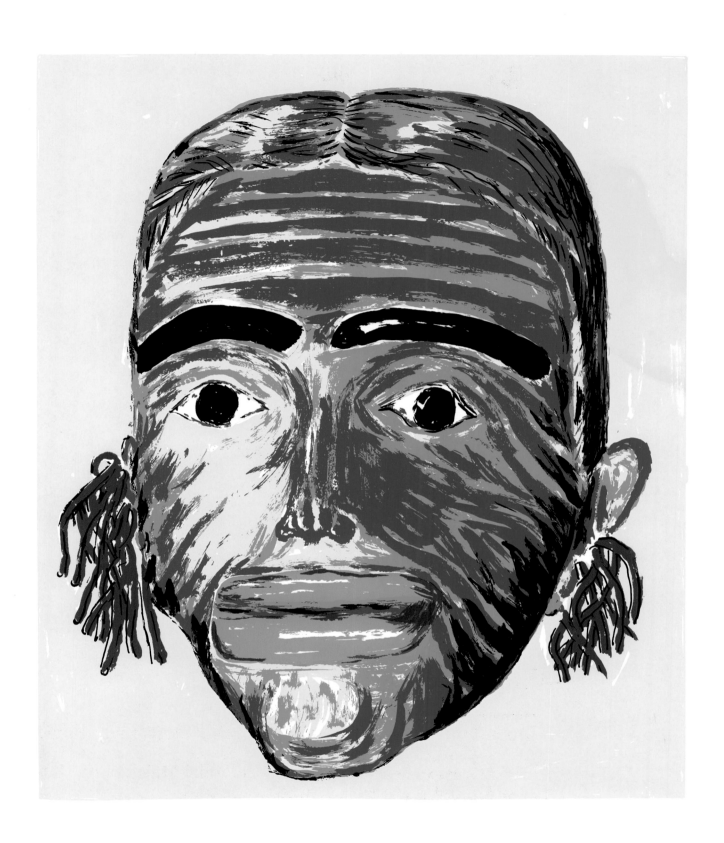

Plate 7

Collected in the Queen Charlotte Islands in 1879 by I.W. Powell, this mask has the following interesting and detailed description in the files of the National Museum of Man:

> MASK: of wood, carved in realistic representation of a man's face, and painted with two-dimensional design. The eyebrows are the typical shape, are in low relief and painted black with red markings. Eyes have a slightly hooded aspect, eyeballs are circular and black, and drilled through at the centre. The mouth has painted red lips, open to expose a double row of teeth carved of ivory. A strip of light-coloured skin extends from either nostril around the corners of the mouth. A triangle of the same skin extends under the chin from the lower centre of the bottom lip. Skin is attached by metal nails. Ears are realistically carved in low relief and painted red. The central portion of the mask is painted blue with traces of red. The sides and chin area are painted with parallel horizontal red lines. On the lower cheeks, between ear and mouth, conventionalized ovoid and U-forms are painted in blue and black. On the forehead is another conventionalized design, of ovoid and U-forms, in red and black. The rim of the mask has a tapering groove extending down either side to the ear, from the centre top. Skin ties are attached in two places at either side.

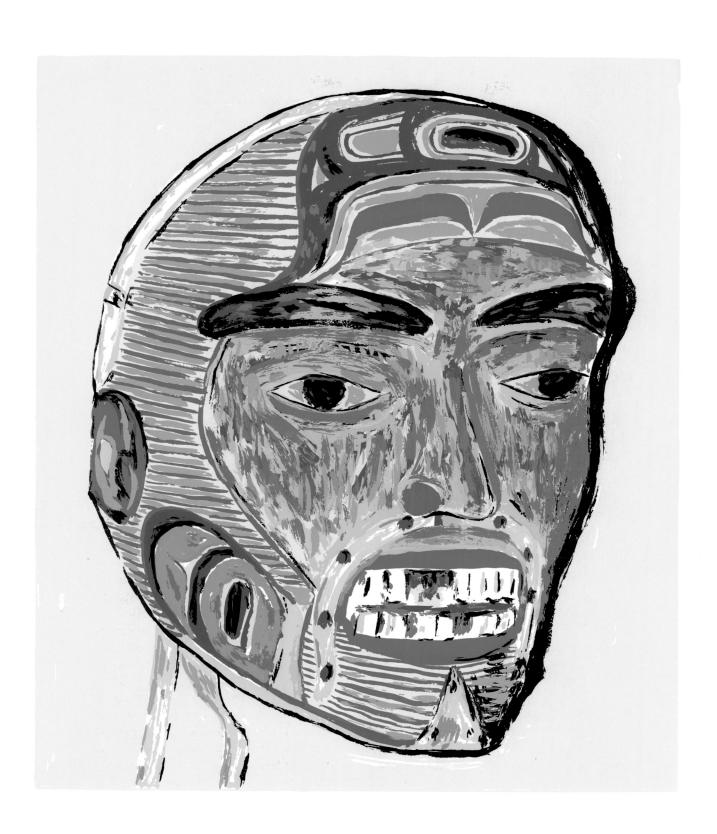

TSIMSHIAN

Plate 8

This Tsimshian mask depicts a sick man. Carved of balsa
wood, it is painted in bright blue and red colours. Holes are
cut out for eyes and mouth. *

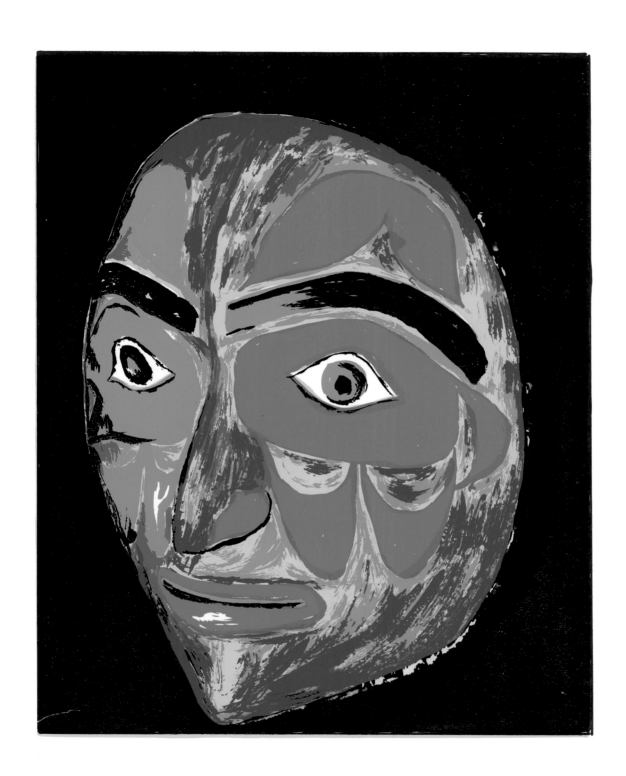

Plate 9

This moon mask was collected on the Nass River by J. Priestley and/or his wife who were settlers and shopkeepers at Aiyansh on the upper Nass River. It was sold to C.F. Newcombe in 1909 and the BCPM purchased the Newcombe collection in 1961.

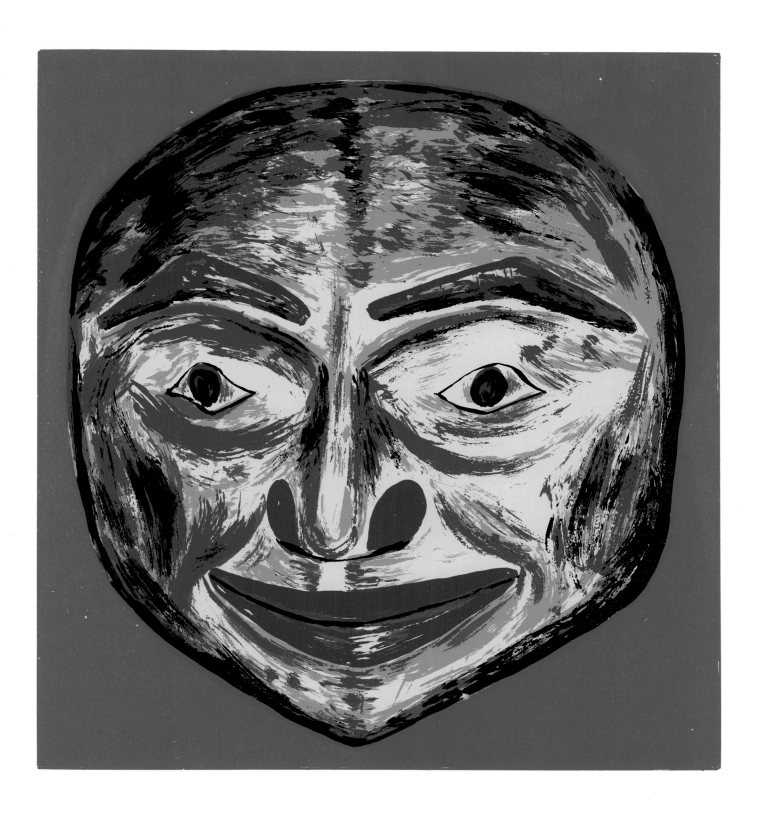

Plate 10

This particular mask, acquired by the BCPM in 1957, was collected by Wilson Duff at Kitwanga on the Skeena River from a Mrs. M.V. Harris. Made of black cottonwood, the mask has corolla and eyes inlaid with mirror glass. It may, at one time, have been used as a frontlet for a chief's diadem.

At what can only be termed theatrical performances, the moon masks were sometimes brought before a curtain on ropes. The mask would be asked if it was really the moon itself come down from the sky. When it answered in the affirmative, it would be whisked away as a chorus sang.

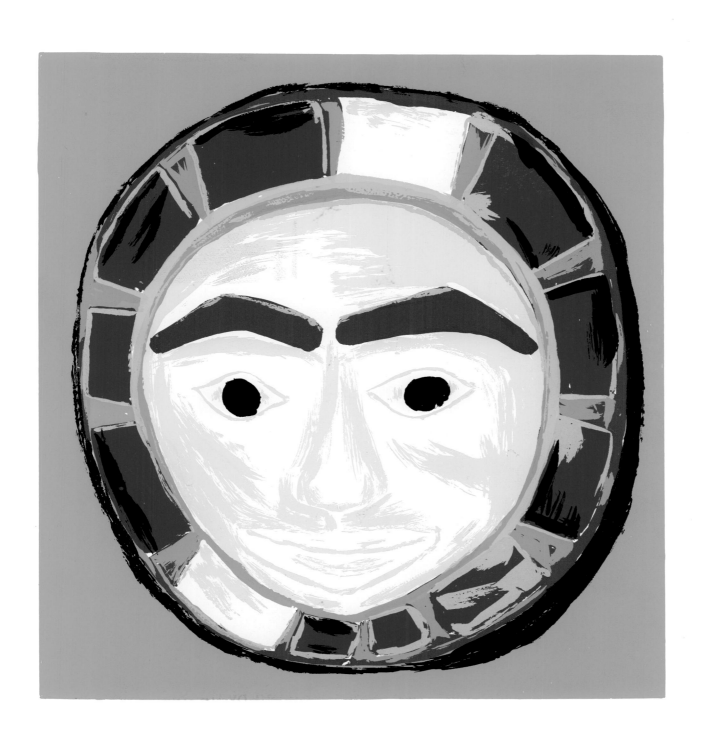

Plate 11

This Tsimshian wooden mask has a moveable top. The predominant colour of the mask is light blue. Nostrils and lips are painted pink. The eyes and eyebrows are black. The cheeks are sharply cut in around the nose.

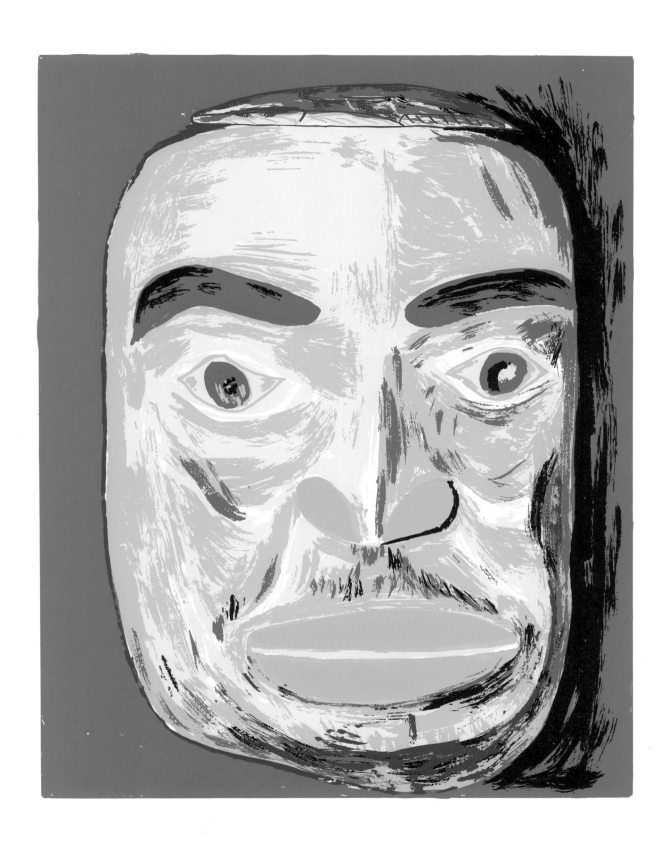

Plate 12

This wooden mask is painted in shades of blue. Nostrils and lips are painted red. The separately carved teeth are nailed into the mouth.

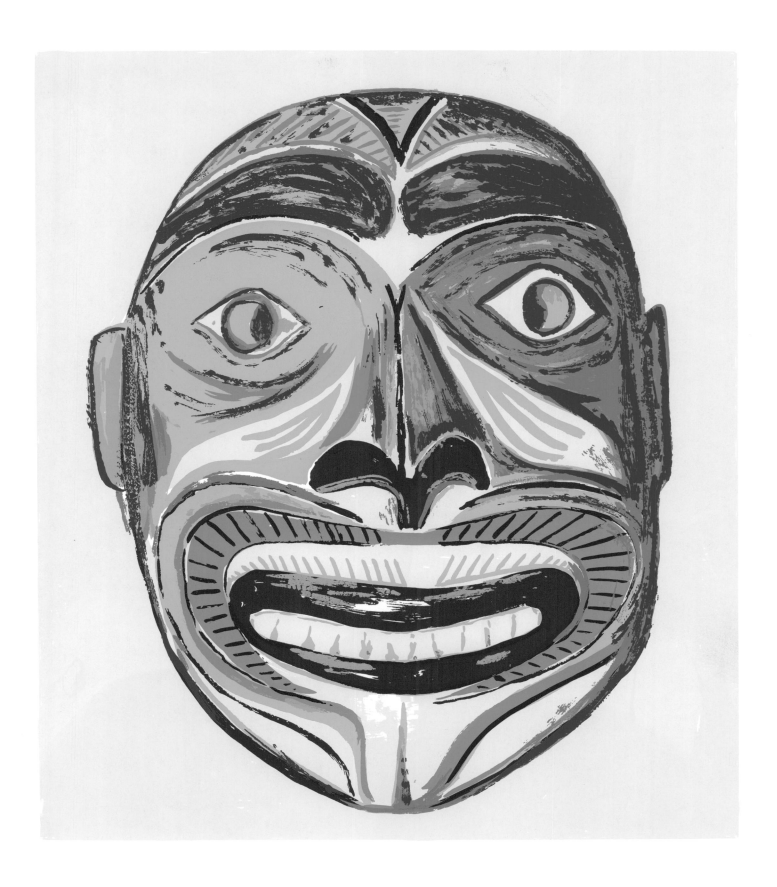

Plate 13

This mask, depicting a man's face, is carved from balsa wood and is painted in dark blue and red colours. It was worn during ceremonials, and the face of the wearer was also painted blue. *

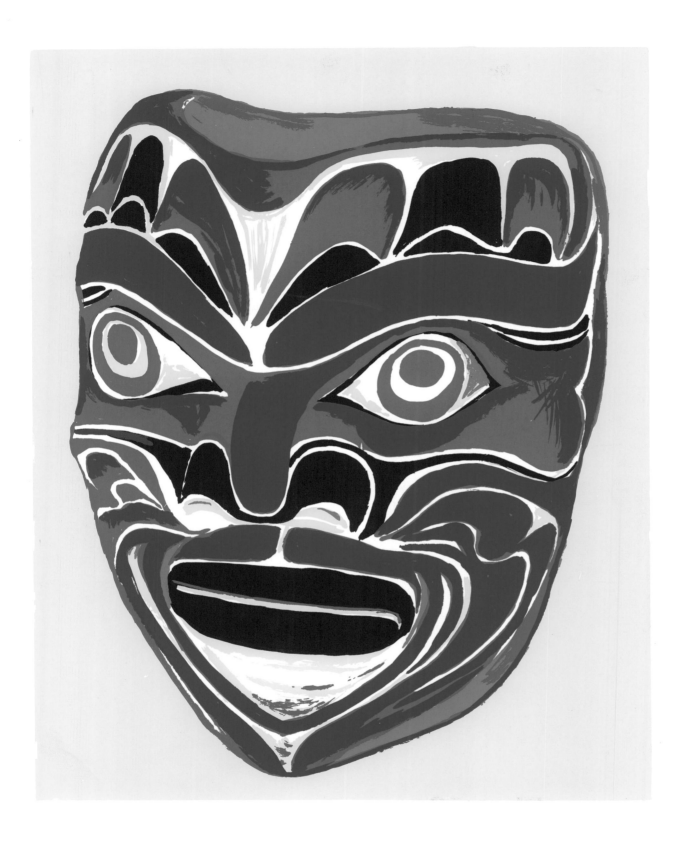

Plate 14

This eagle mask has a moveable lower beak with the jaw pegged in place. It was probably operated by a string during a performance. Notice the crescent nostrils, which are typical of these eagle masks.

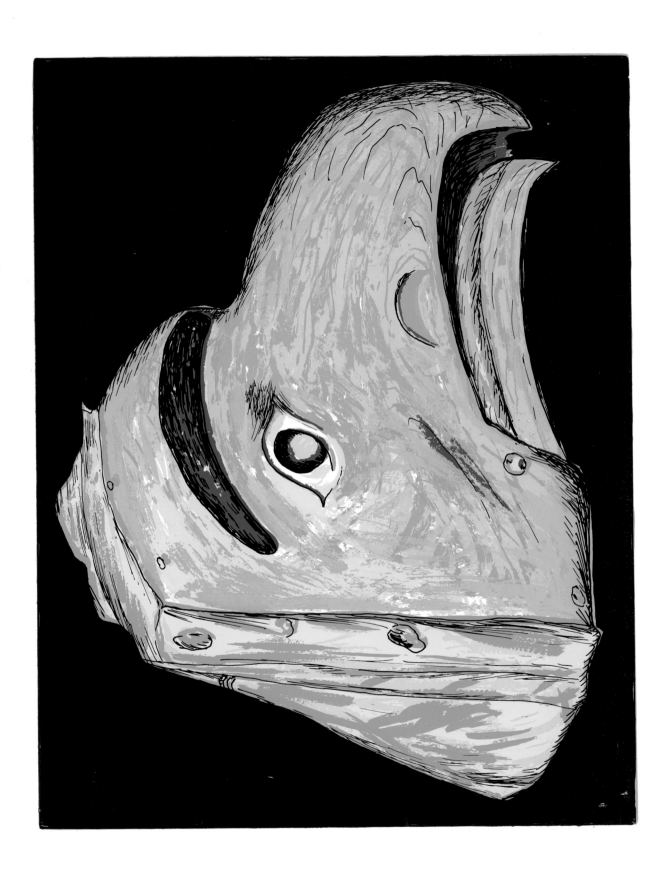

Plate 15

This mask was collected at Gitksan by C.M. Barbeau in 1923. In the film "The Loon's Necklace" it was "Night Wind" probably because of the mouth puckered into an "O" as if blowing. The National Museum of Man designates it as "Corpse or Ghost" and also as "Chief of the House". In connection with the latter title, there is the following note: "Their performer wearing the mask went around the house. All those who faced it fell down and twisted around; the others gave him something to drink and he recovered."

The nose is sharply pointed and the brows and eyes are outlined in red. It ties at the back with leather thongs.

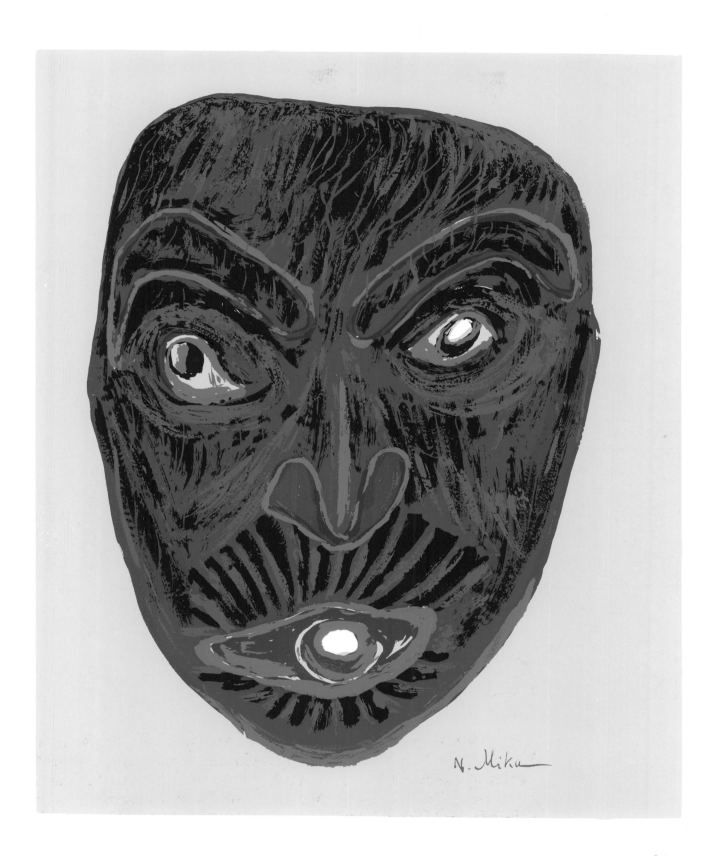

Plate 16

The mask is carved of wood and stained dark brown with a few outlines in blue and dark pink.
Found near a burial ground, it was probably worn in winter ceremonial dances. *

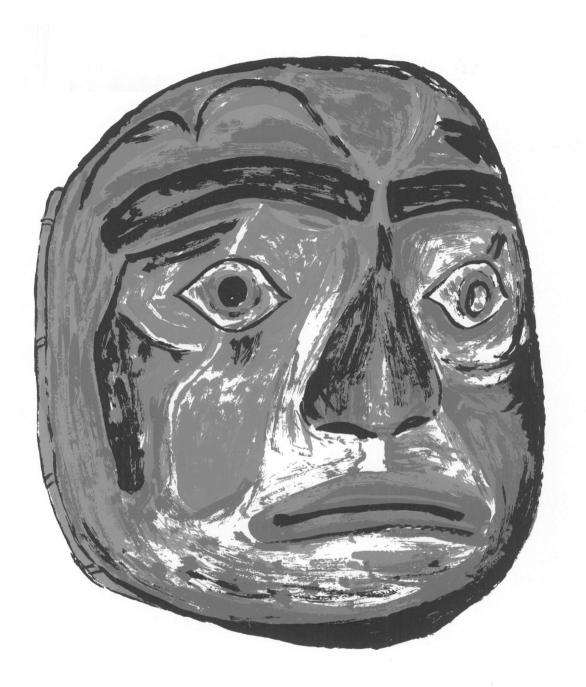

Plate 17

On this mask the eyes have been burned through, the nostrils cut through and the mouth slit through. The most interesting features are the looping designs above the eyebrows and on the lower cheeks, and the way in which the artist has balanced the red and blue designs on each side of the face.

There are two holes in each side of the mask and one on top to which leather and string fastening are joined. There is also a rectangular nail at the top of the mask.

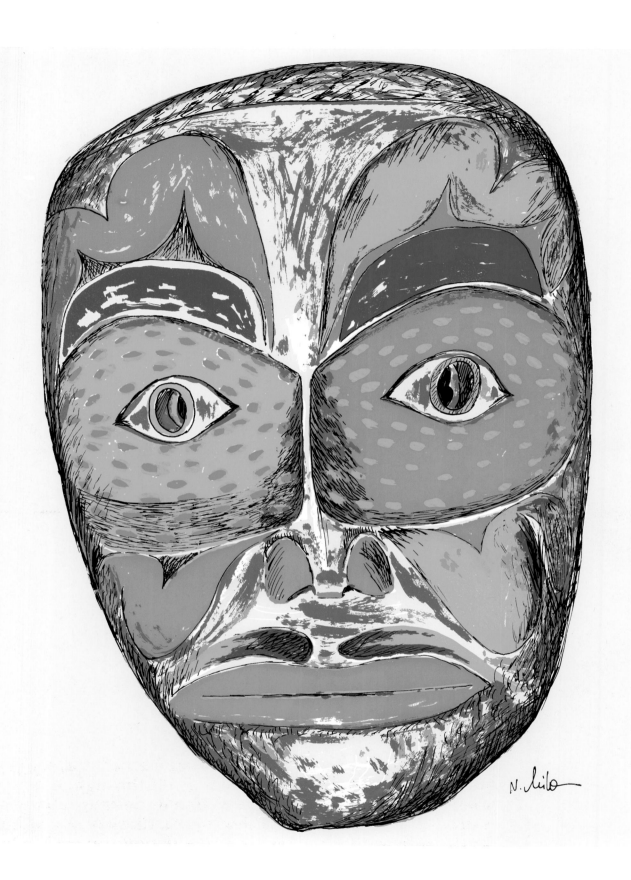

Plate 18

There are both eye and nose holes on this largish wooden face mask and there is low relief carving for the eyes and around the nostrils. On the eyebrows, pupils, moustache, and cheek "U" forms there is the same darkish colour. Besides the red on the lips and nostrils and beneath the eyebrows, there are red dots within the cheek "U" forms and on the forehead and sides of the face. The rest of the face is white. Generally speaking the painting is rough. There are leather thongs lashed to the side holes.

The documentation on this mask at the National Museum of Man indicates that it came from Tommy Brown of the Gitksan and was "purchased by J.C. Spencer for C.M. Barbeau."

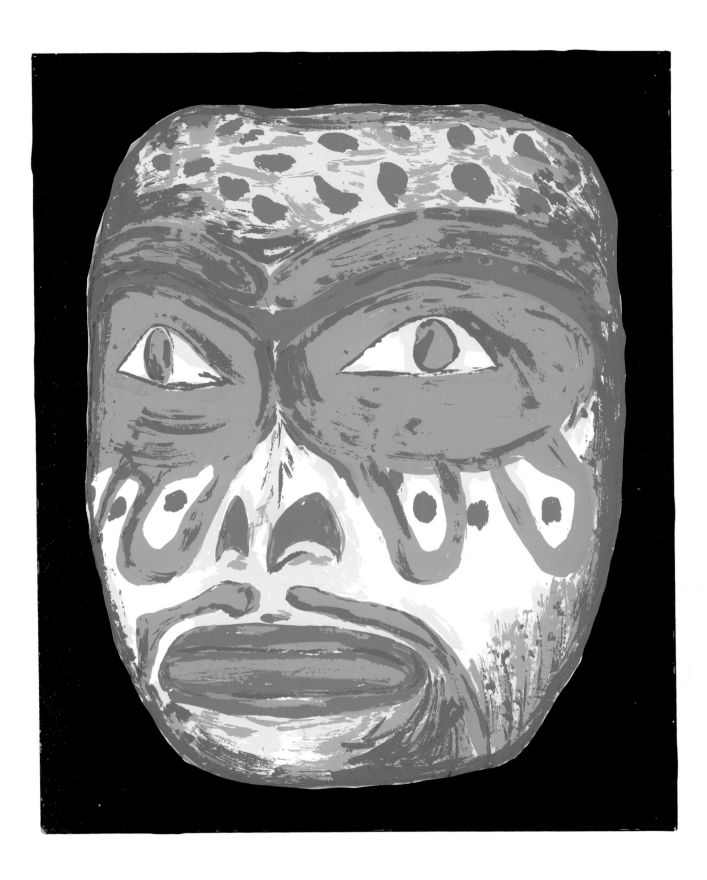

Plate 19

This stained wooden mask with its symmetrical design uses mainly blue-gray colour. Holes are cut out for eyes and nostrils, and there is a slit cut through for the mouth. *

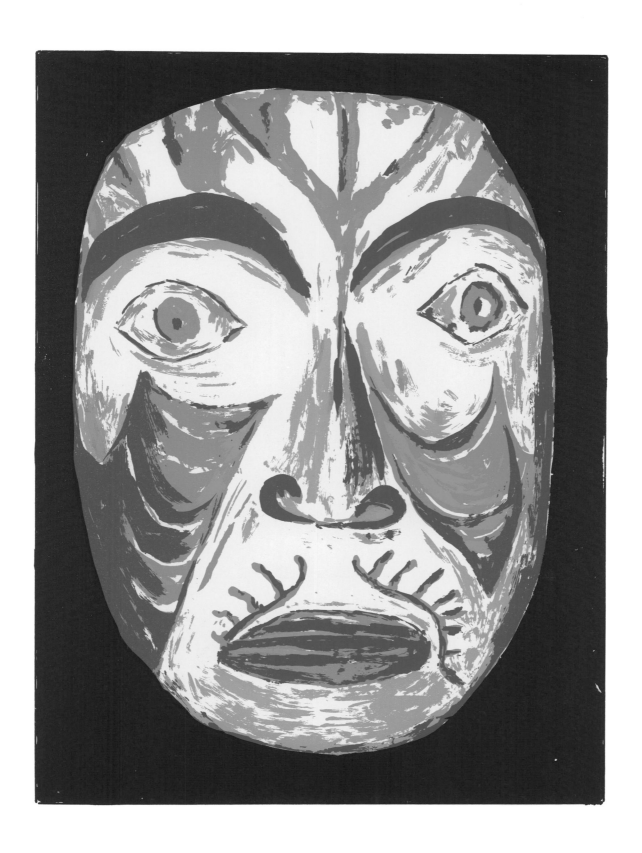

KWAKIUTL

Plate 20

This is an arresting example of the Hawk Spirit Mask. It comes from Alert Bay in British Columbia and was collected by D.C. Scott in 1922.

The artist has used brass washers for the iris of the eye and holes for pupils. Along the hairline are fuchsia-dyed chicken feathers and at the centre of the head brown human hair. Bark and twigs are tied to a wooden strut with red cotton, and there are even some eagle feathers among the conglomeration of materials. There is a hole through the chin area.

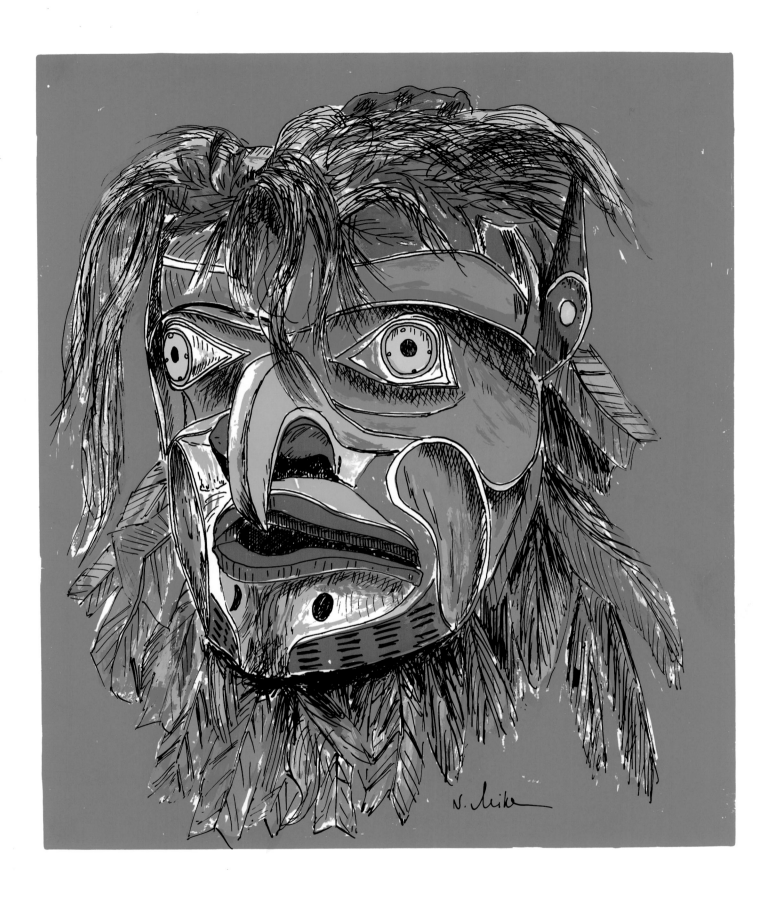

Plate 21

This mask probably is meant to represent a bird. Around the outside are tufts of horsehair and on the rim of the mask is an inlay of abalone that acts as a corona. The mask proper is made from a single piece of wood but the eyes are made from bulging brass discs. There are knotted leather thongs at the back so the mask can be attached to the head.

This mask was collected in Nanaimo, B.C. in 1929 by H.I. Smith.

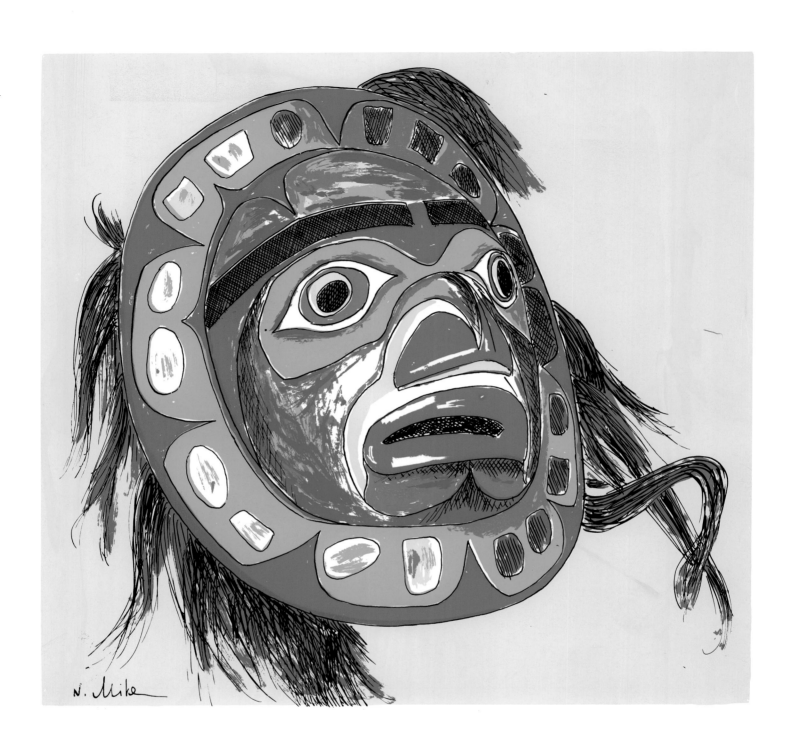

N. Mike

Plate 22

This Kwakiutl wooden mask was probably designed for mourning ceremonies. Carved from a single piece of soft wood, it deliberately features a very long nose. The mask is painted red and blue. *

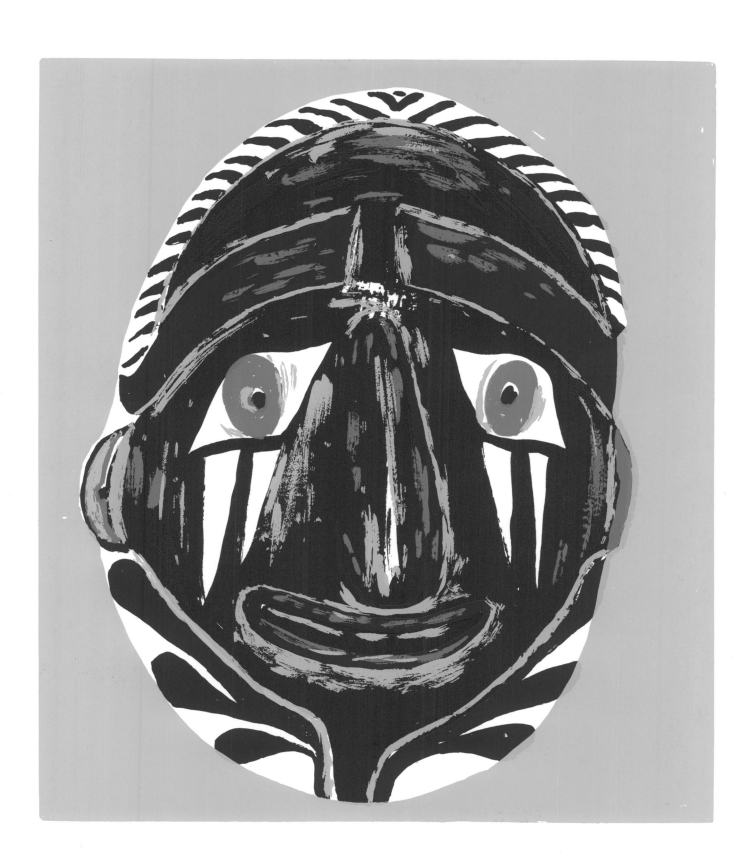

Plate 23

This mask, which is made of red cedar, horsehair and fur, was collected in the Alert Bay area in the early 1900's. It is described in the Royal Ontario Museum files as "the mask of a 'sleepy Tsonoqoa'."

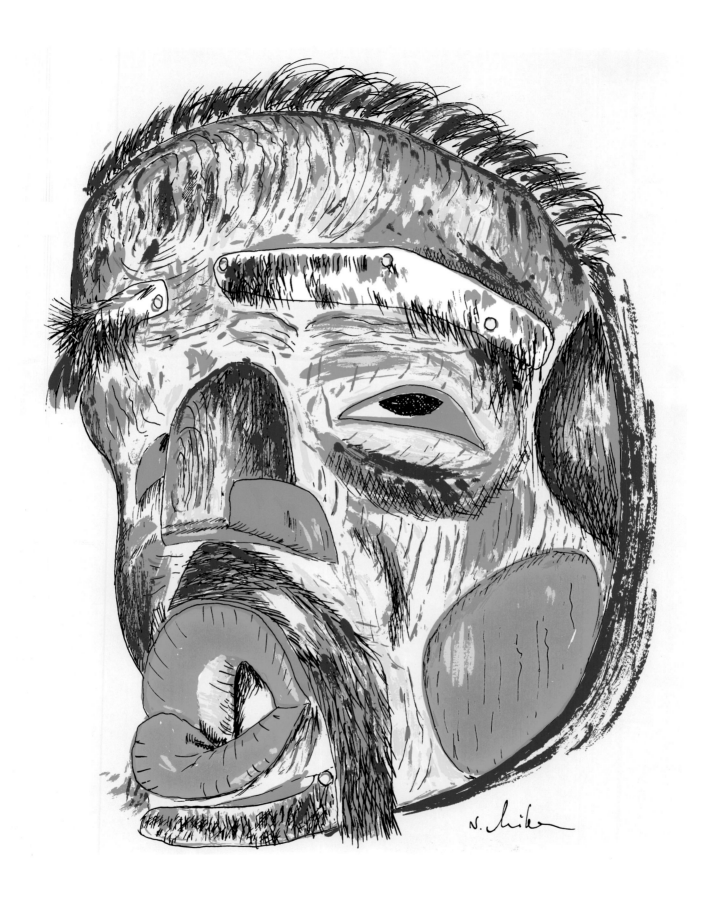

Plate 24

This **Kwakiutl Bookwus** mask comes from Alert Bay. The carver certainly **succeeded** in creating a fierce expression on the face of **the mask. The** nose resembles the beak of a hawk, the eyes are **burned through**, the nostrils are cut out, and the mouth flashes **two rows of large** teeth. Human hair was used to complete the **mask.** *

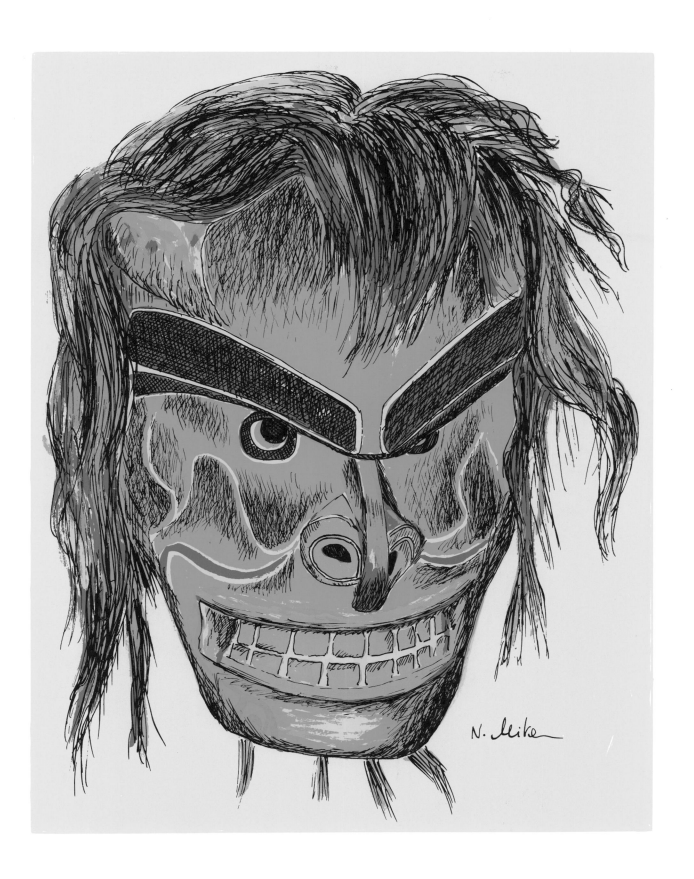

Plate 25

This Kwakiutl Komokwa mask may have come from Sullivan Bay. There are holes both for the eyes and the nostrils. Lips and the outlines of the nostrils are painted red, while the heavy eyebrows are drawn in a deep blue.

The mask is carved of beautifully grained wood. *

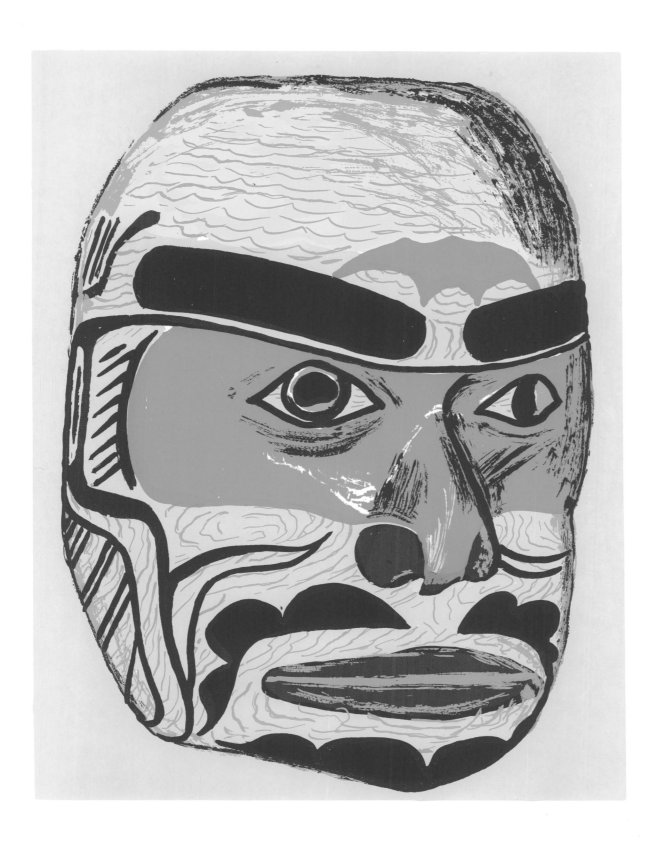

Plate 26

This mask, which was collected from Alert Bay in the early 1900's, is made of red cedar and rope.

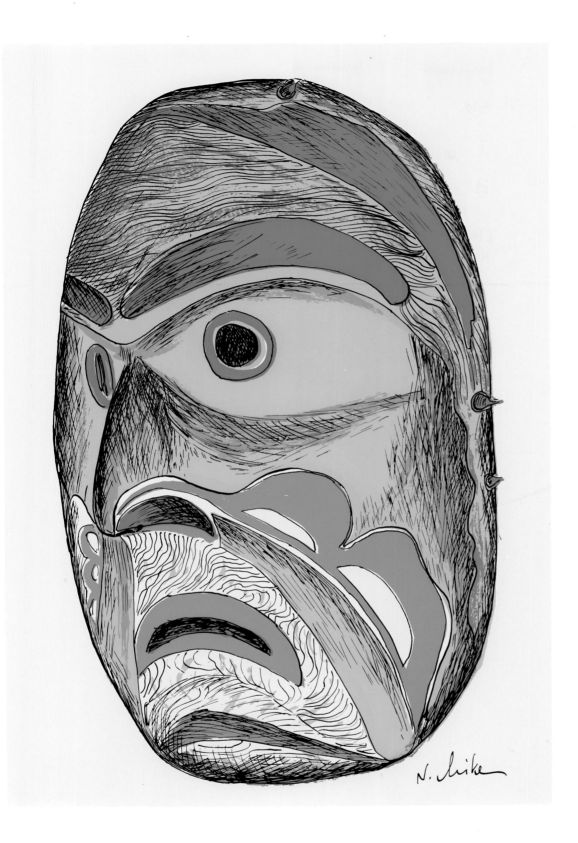

Plate 27

This mask was collected in the area of Alert Bay in the early 1900's. It is made of wood.

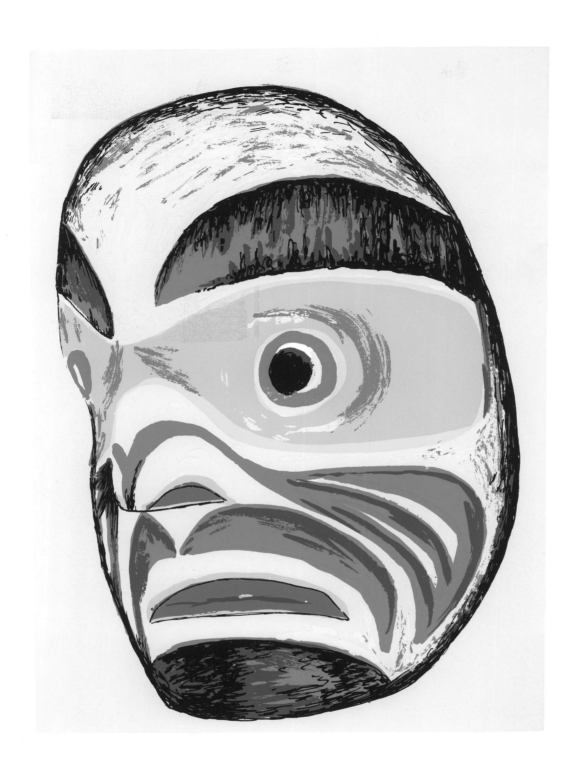

Plate 28

This red cedar face mask is painted in rust and blue colours. The eyes are outlined in blue while the cheeks, mouth and chin, as well as the top of the head, are marked in rust. The mask is trimmed with human hair.

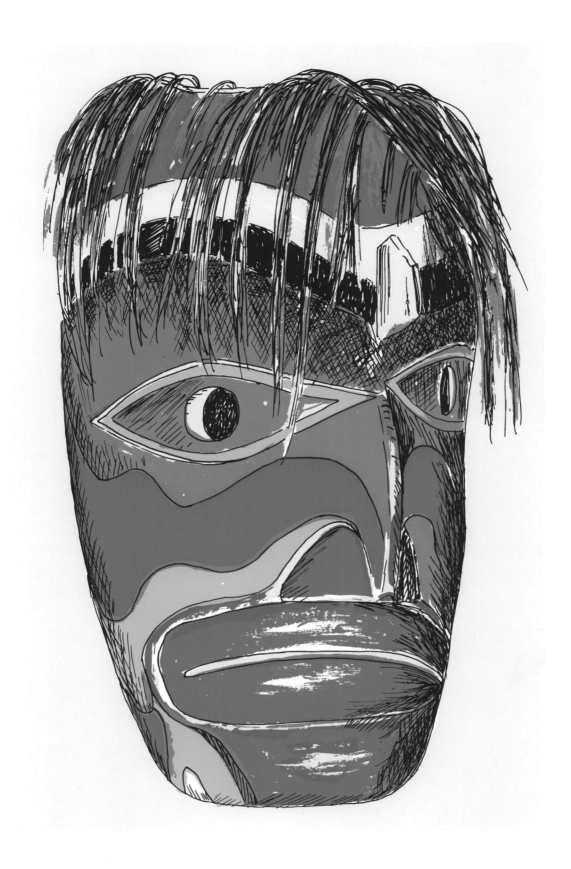

Plate 29

This mask is 33 inches long and is undoubtedly one of those heavier masks requiring the counterbalancing of a wooden frame. A string ran from this frame to the waist of the dancer and strings controlled the mechanism of the beak which had leather hinges. The wig is a mixture of unpainted cedar bark and bark that has been alder-dyed. Such large masks were part of the dances of the Hamatsa Society. Using such masks, the dancers—covered in branches and leaves—would hop around while squatting and would rhythmically clatter the beaks.

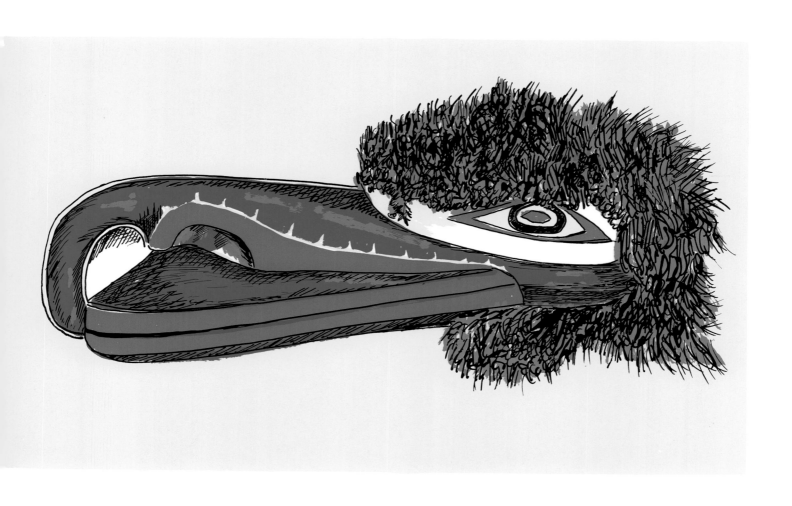

NOOTKA

Plate 30

Because of a Nootka tribal myth in which the son of an ancestral chief was kidnapped and initiated into wolf lore, this tribe centred its winter festivals around wolves. Chiefs would bring out their family headdress-masks such as the one in Plate 30. During the winter ceremonies, all the villagers would participate and initiates could be slaves as well as children.

There are four holes cut out of the back wavy edge of this mask; cedar bark is knotted through the holes.

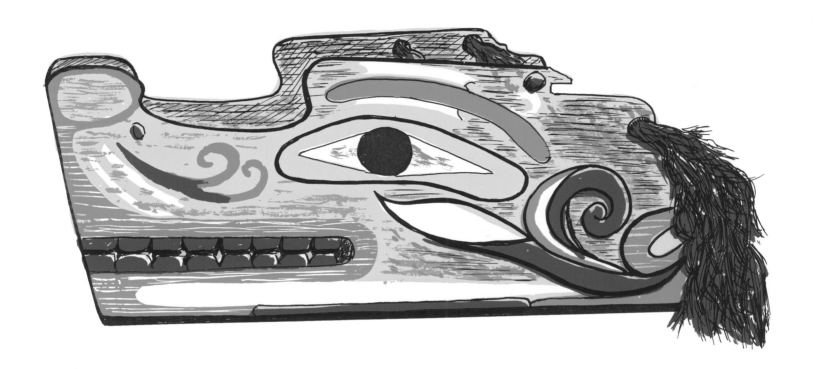

Plate 31

This is probably intended to be an eagle mask. In the top edge there is a series of holes into which four inch clusters of brown, human hair have been inserted. The measurements are 16½'' by 8'' by 7''.

The mask was collected by Lord Bossom around 1900.

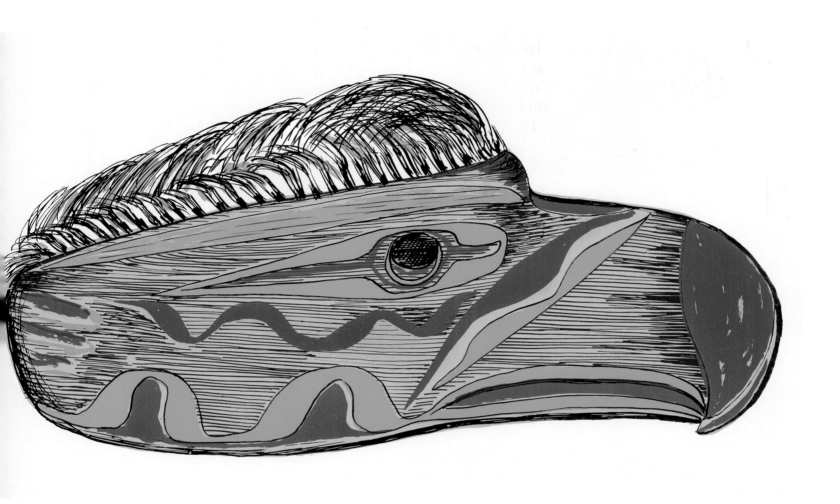

Plate 32

This is a Nootka dancing mask made of wood. Besides the hole under the nose, there are holes on each side and the top of this mask. The mask was once covered in white paint but most of it has worn off or cracked.

Franz Boas, the famous German-American anthropologist, collected this specimen in 1889 during his investigations of the Indian tribes of British Columbia.

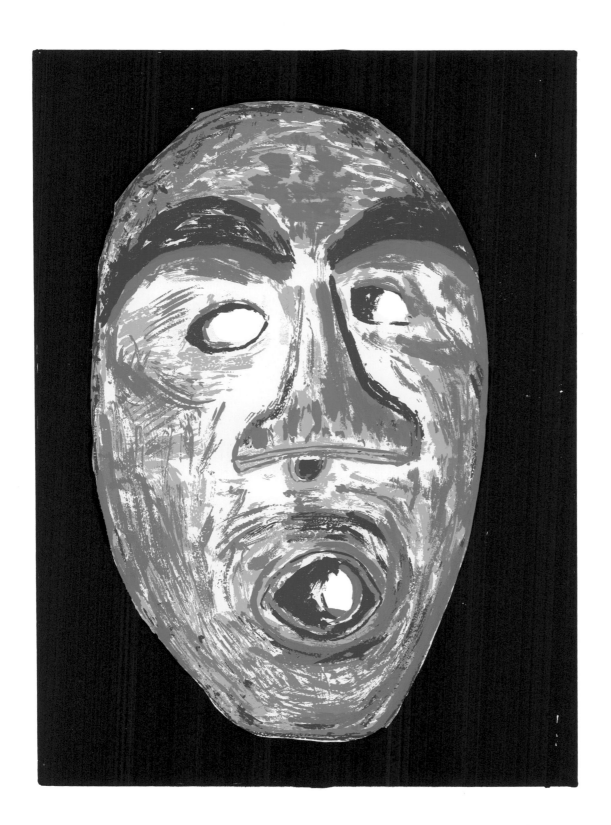

Plate 33

Said to represent a male "wild person" this wooden face mask comes from Alberni, British Columbia. It was collected by Edward Sapir in 1910.

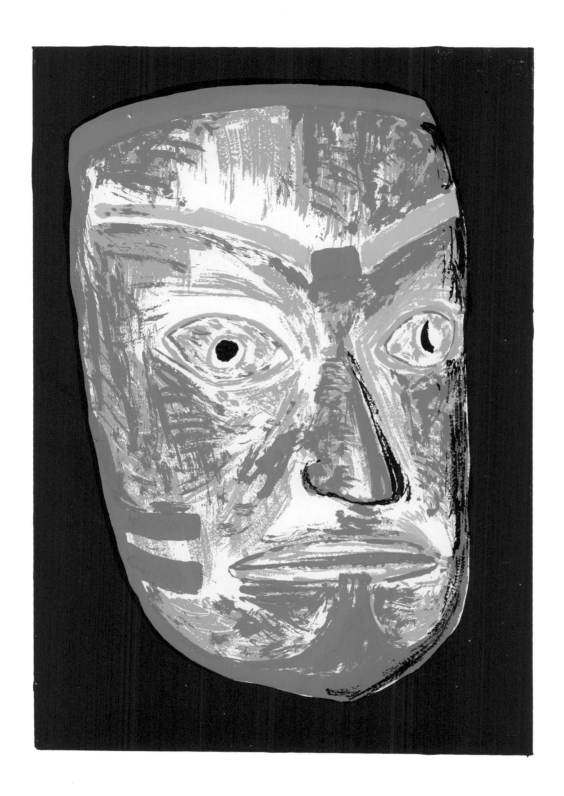

BELLA COOLA

Plate 34

This mask has unusual cat-like ears. The protruding, wide, red lips are slightly parted. There are large circular holes for the pupils of the eyes, and crescents are cut into the cheeks. High areas of the face are painted black, the low areas white.

From Rivers Inlet, this mask was collected in 1923 by H.I. Smith.

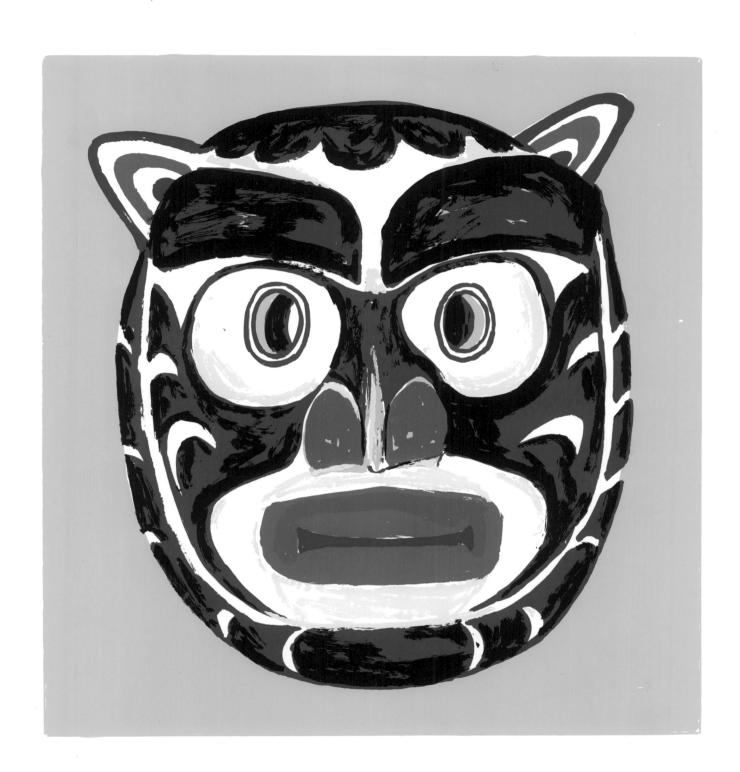

Plate 35

This mask was collected from the "Stick" Indians in the early 1900's and is made of wood.

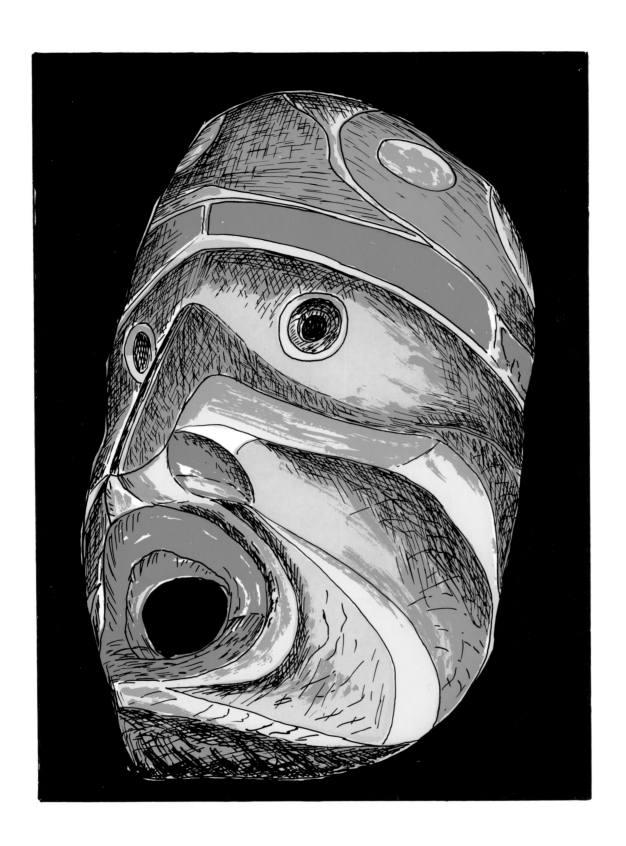

Plate 36

A Royal Ontario Museum record card states that this mask was collected in the early 1900's and is made of "wood, with leather now bare of original fur." Under "subject" it is given as possibly a "Bookwus Mask."

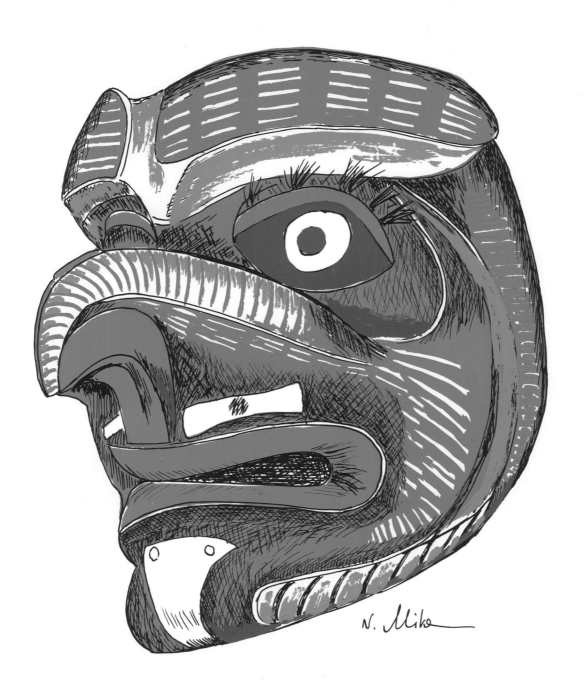

Plate 37

Known as a blind or transformation mask this strange face (with its projecting chin and flat nose) has eye holes underneath a moveable forehead visor. When this visor—a separate piece of wood operated by strings running through the main mask—is down, the wearer of the mask is blind.

This mask was made originally for the presentation of an Indian myth such as "The Loon's Necklace". The story concerns a blind medicine man named Dark Night who, one cold and hungry winter, was told by his totem bird, the loon, that wolves would attack the village. Although Dark Night warned the council, he was not believed. When, however, wolves did attack and kill many people, Dark Night was asked to take his magic bow and defend the village. For the rest of the winter, the medicine man slew every wolf he aimed at and so provided his people with food.

In the spring as Dark Night sat in front of the special house the tribe had built for him, he heard the loon call from the lake. Taking his most valuable possession, a shell necklace, he crawled to the water and asked the loon to give him his sight. "Sit on my back and hang onto my wings," was the reply. After Dark Night had dived with the loon four times, he found that he could see again. Overjoyed, he threw his necklace around the neck of the loon and some of the shells sprinkled over the bird's back and wings. Ever since then the loon has proudly worn his necklace.

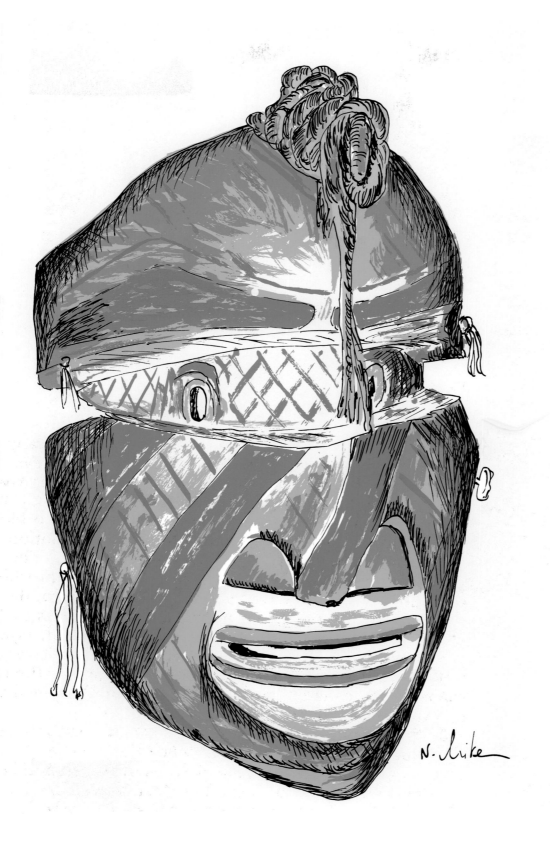

Plate 38

The frightful quality of this mask comes from the gaps between the teeth, the extreme hawklike nose, and the bulbous chin and forehead. The nose is separately nailed on. In all there are six pieces of wood. On the cheeks are three-pointed stars.

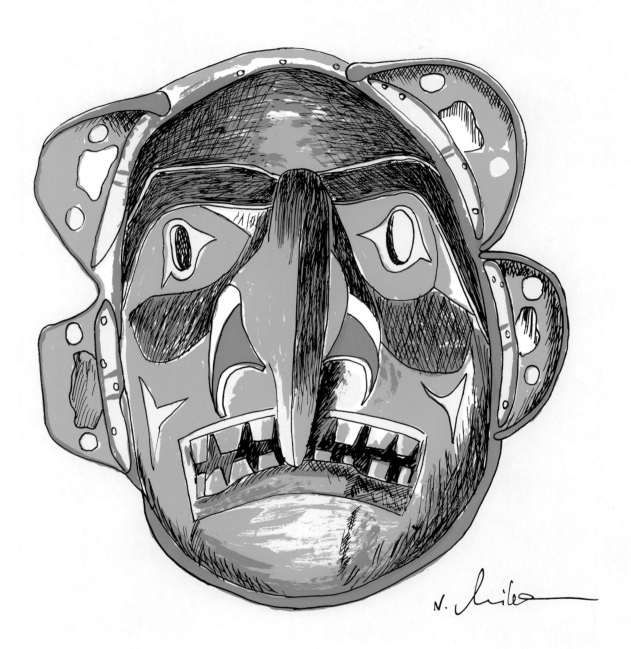

Plate 39

This face of a man is made out of wood. The mouth is open, the cheeks flat and the eye holes have been drilled out. The brows and moustache are painted black. Besides the blue around the eyes, there are traces on the cheeks and chin. The nostrils are reddish.

This Bella Bella mask was collected by Aaronson and came into the possession of the National Museum of Man in July, 1899.

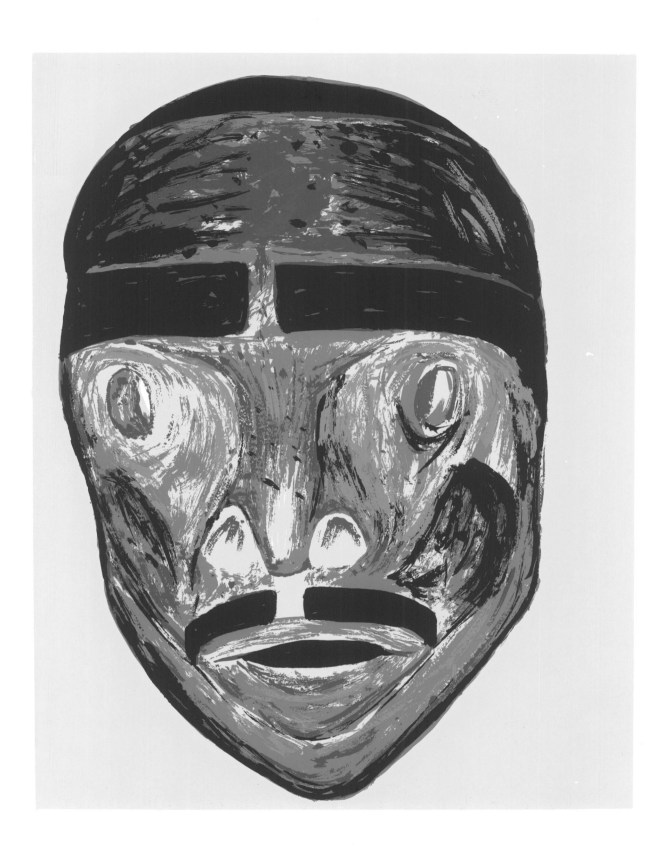

Plate 40

This dramatic Bella Coola Indian mask is made of red cedar and stained in light brown. Nostrils and lips are painted in a deep red. The hair is of human origin. *

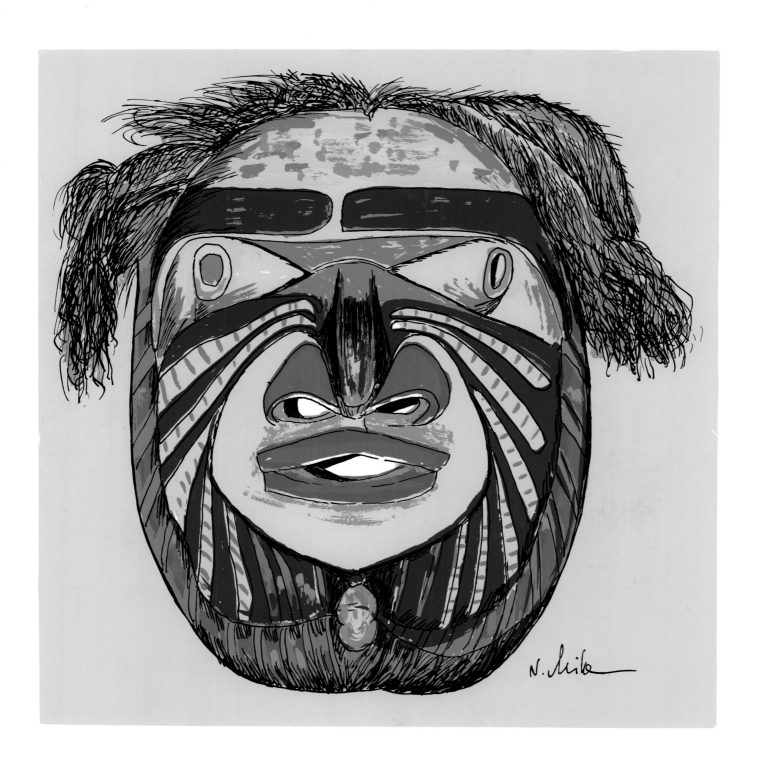

Plate 41

A notation accompanying this mask in the files of the National Museum of Man in Ottawa states that it was worn by "the leader of the choir" during a Kusiut dance. "When this Kusiut dance is performed, the singers—contrary to custom—are masked." It adds that "men sing and beat time for a dancer accompanying Noäxxem."

This mask was collected by T.F. McIlwraith in 1924.

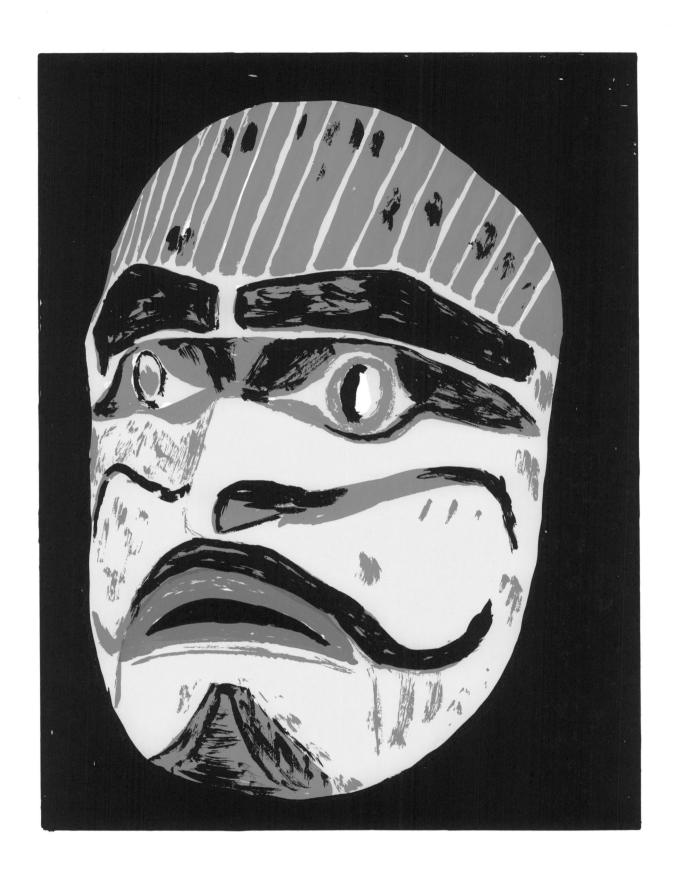

Plate 42

This mask, used as the frontispiece of this volume, comes from Taliho, South Bentinck Arm, British Columbia and was collected by H.I. Smith in 1923. It is a dancer's mask.

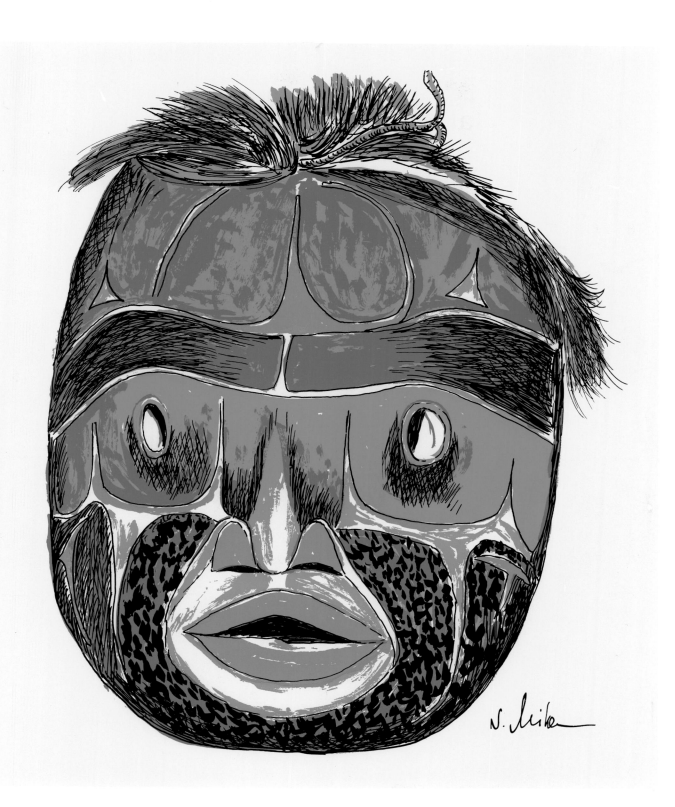

Plate 43

The measurements of this mask of a man, approximately 13½'' by 12'', are unusually large. There are holes on the top of the head and on each side so that the mask can be tied onto the head. The interior of the mask is chiselled and the hole for the nose branches into two nostrils.

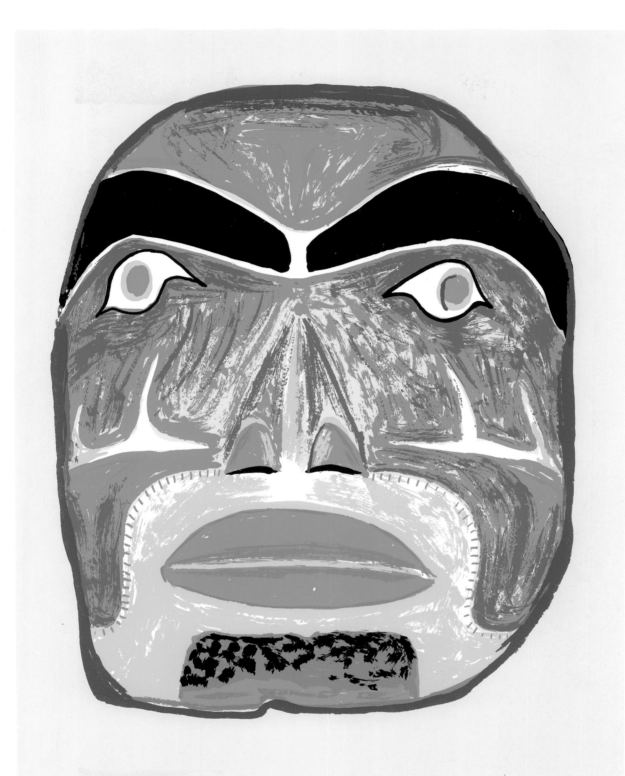

IROQUOIS

Plate 44

This is one of the wooden masks worn by the members of the Iroquois False Face Society in the 19th century. A silver plate with two openings for the eyes is fastened to the wood. The mask is trimmed with horsehair. *

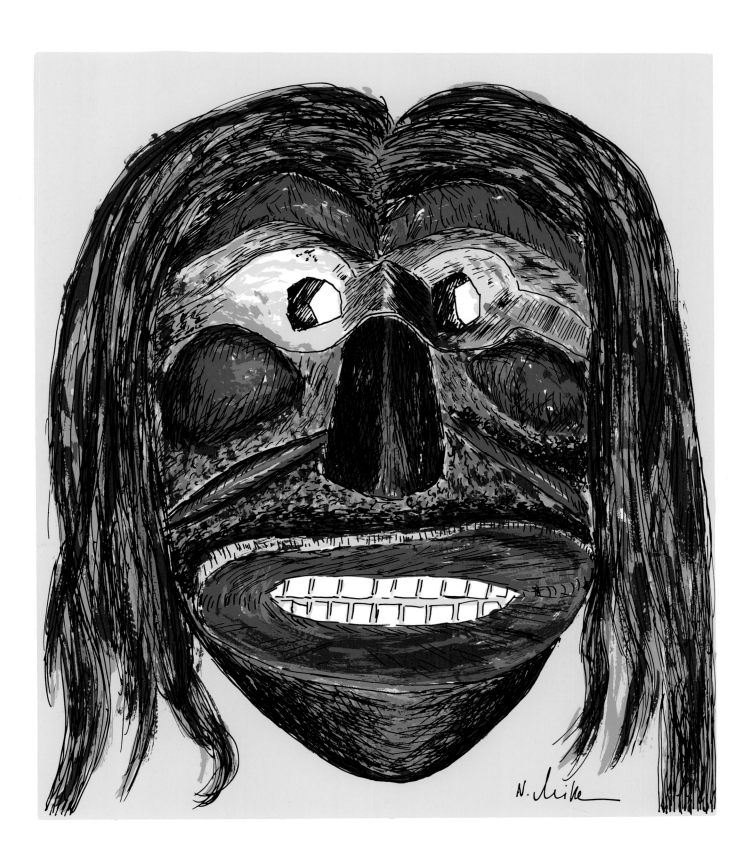

Plate 45

This mask is made of wood, brass and horsehair. Interesting features include the wrinkled forehead, the arched eyebrows and the brass-plate eyes with holes in the centre and brass nails at the corners. The nose protrudes and has flaring nostrils. The largish, smiling mouth shows both rows of teeth. The chin is pointed. Laced to the top and either side of the mask are hanks of black horsehair.

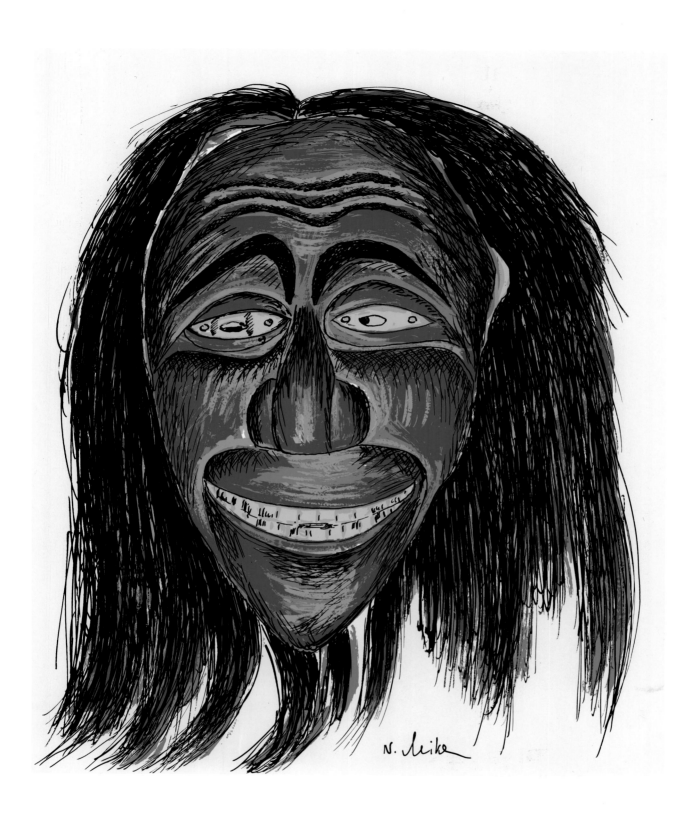

Plate 46

Collected by C.M. Barbeau in 1912, this mask was made by an Indian named Daylight Davis, a member of the Cayuga Iroquois Tribe of the Seneca Reserve in Oklahoma.

A Doctor's wooden False-Face Mask, this interesting face has no eye sockets but round brass plates for eyes. The pointed nose is a long, thin triangle. The hair is in two separate hanks secured at the top of the mask with thick twine and a beige leather thong.

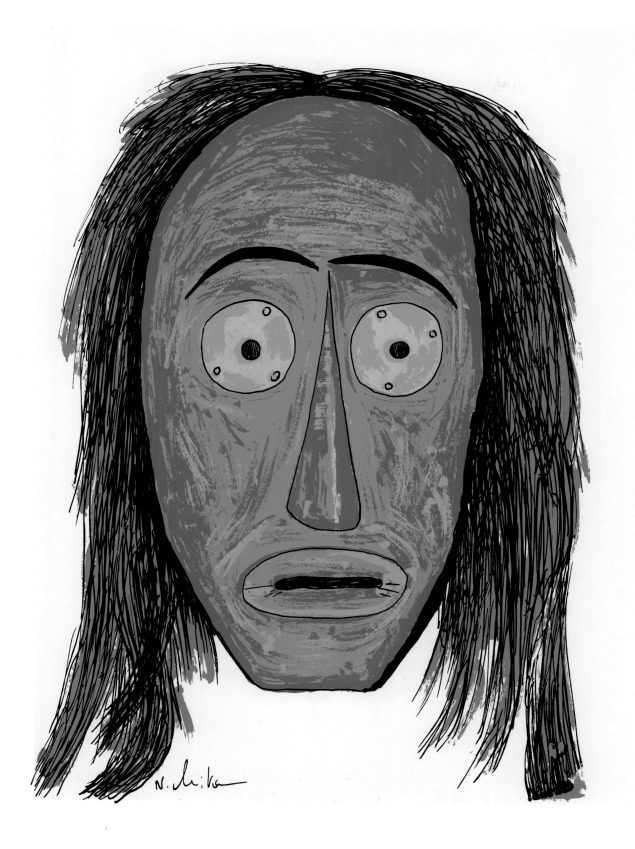

Plate 47

Worn by members of the Iroquois False Face Society this protruding-tongue type of mask was used in medical curing rituals for individuals or families. Made near Brantford, Ontario, on the Six Nations Reserve, it was collected by a Mr. David Boyle in 1899. It is thought to have been created around 1820.

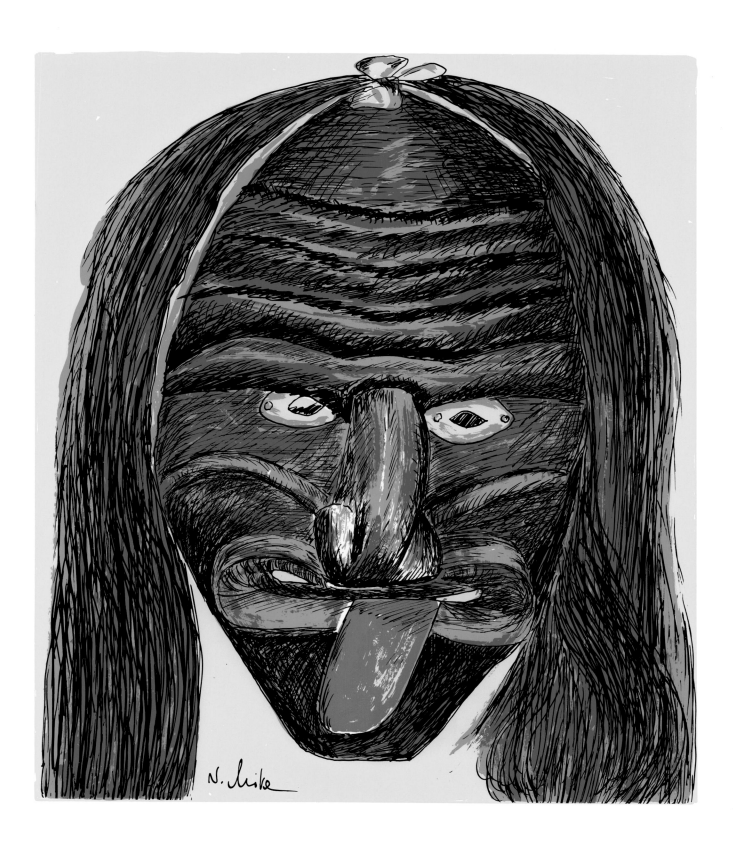

N. Mike

Plate 48

This Iroquois False Face Society mask is made of poplar wood. Two oval silver plates with holes cut out for the eyes, are fastened with silver nails at the corners. Two separate hanks of horsehair are secured at the top of the mask with heavy twine and hang down on either side of the mask. *

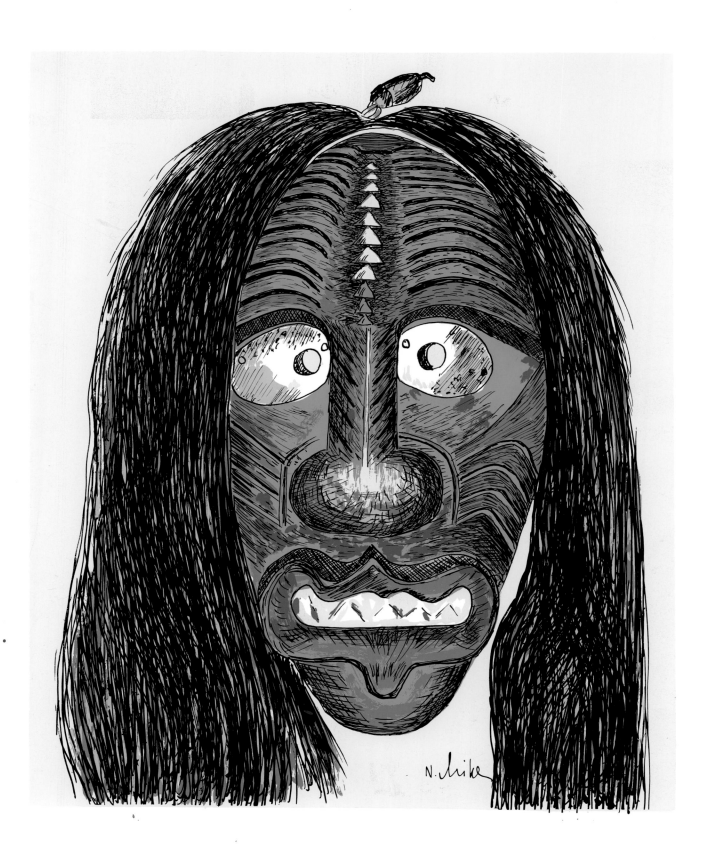

Plate 49

From the Six Nation Reserve in Ontario, this Iroquois (Onondaga) mask is of the crooked-mouth variety and is dated mid-nineteenth century. Made of poplar wood, it has brass eye-plaques and deer teeth and is trimmed with horsehair. It is 32 cm. high.

This is the mask of the Great World-Rim Being otherwise known as False Face or Head Man of All Faces. His face is writhing in pain and his nose is broken because of his contest with the Great Creator.

The Iroquois myth is that when the Great Creator had finished making the earth, he went around expelling the evil spirits from his realm. When he travelled westward, he met the huge chief of all the Faces who claimed to have lived in the Rocky Mountains since he created the earth. An argument ensued between them about who was the creator and whose territory the earth was. To decide the matter they were both to sit facing the east and one after the other to summon a mountain to them. After making a great deal of noise with his turtle rattle, the Great World-Rim Being could only bring the mountain part way. When it was the turn of the Great Creator he was able to bring the mountain right to them but evidently too slowly for the impatient False Face who spun around to have a look. The mountain struck him, broke his nose and twisted his face in pain.

As a result of the contest, the Great Creator recognized that his rival had magical powers which could be put to use. He assigned him the task of chasing out diseases and helping hunters. In accepting this role, the Great World-Rim Being said that if humans put his face on masks, left him mush to eat and called him grandfather, they would be able to drive diseases out of people by blowing ashes on the afflicted person.

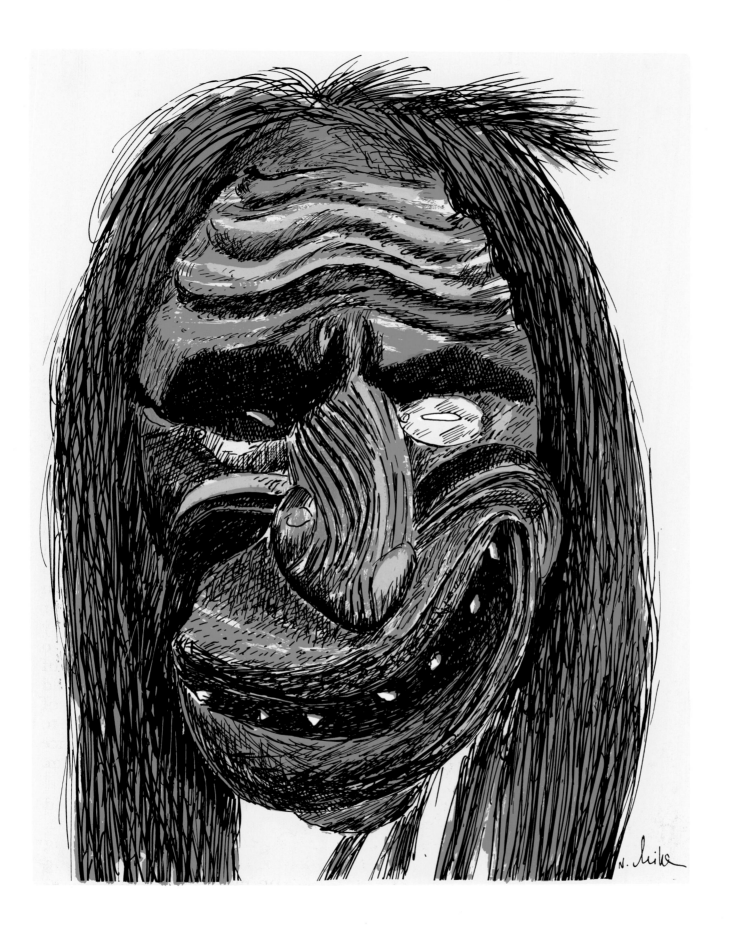

Plate 50

The Husk Face Society was one of the False Face Societies of the Iroquois which performed ritual curing ceremonies in spring and fall and when anyone was ill. This particular mask is made out of corn husks. Among the Iroquois the "Three Sisters"—corn, beans and squash—were spirits accorded respectful acknowledgement. The three vegetables were the main tribal crops and were preserved in winter (1) in underground caches covered by earth; (2) in chests inside the Longhouses; or (3) in specially made granaries.

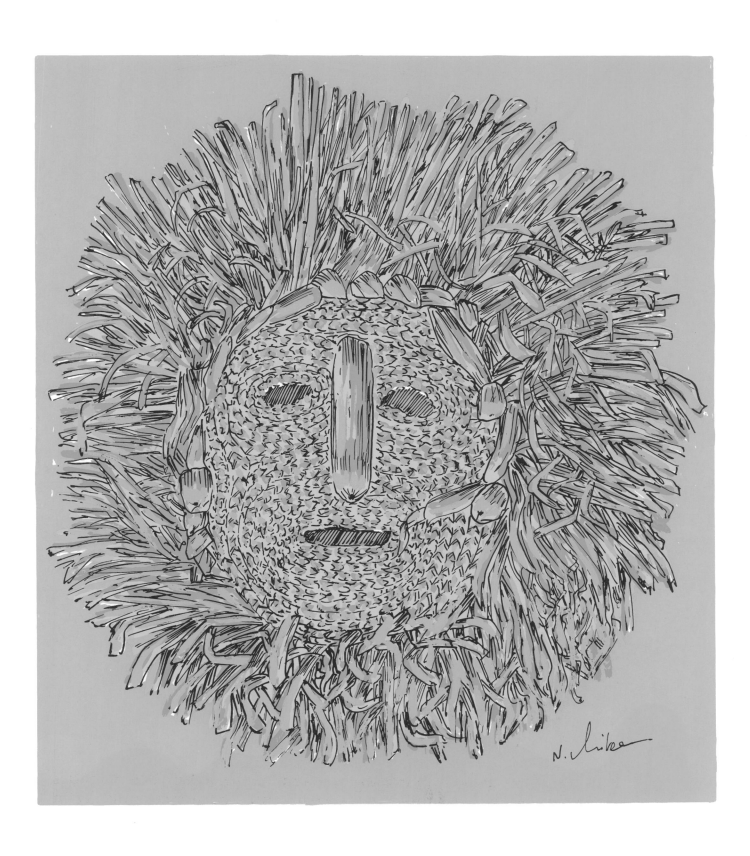

NOTES

[1] The transformation of the initiate is no doubt symbolized with special vividness by those metamorphic masks which open to reveal a second aspect. A Haida mask, for instance, when closed represents the head of Raven as bird, and open Raven as man.

[2] Captain James Cook, *A Voyage to the Pacific Ocean. . .*, vol. 2 (London, 1784), p. 273.

[3] Cook, p. 307.

[4] Cook, p. 307.

[5] Details concerning these masks are given in Erna Gunther, *Indian Life on the Northwest Coast of North America* (Chicago and London, 1972), Appendix I, pp. 224–226.

[6] A footnote by the translator Newcombe states that "The wooden frame behind the mask also acted as a counterbalance and generally had a string from it to the waist."

[7] Newcombe says "These mechanical dolls were used by certain secret societies of the Haida, Tsimshian, and Kwakiutl."

[8] "Masks with the upper jaw moveable are a rarity." (Newcombe)

[9] Jacinto Caamaño, "Journal", ed. by Henry R. Wagner and W.A. Newcombe, *British Columbia Historical Quarterly*, vol. 2, 1938, pp. 288-293.

[10] George Woodcock, *People of the Coast: The Indians of the Pacific Northwest* (Edmonton, 1977), p. 104.

[11] For further details see Diamond Jenness, *The Indians of Canada* (Ottawa, 1963), p. 203.

[12] H.R. Hays, *Children of the Raven: The Seven Indian Nations of the Northwest Coast* (New York, 1975), p. 168.

[13] A. Menzies, *Journal of Vancouver's Voyage* (Victoria, 1923), pp. 118-9.

Select Bibliography

Bibliographical guides are contained in most of the books in this list.

Boas, Franz. Ed. by Helen Codere. *Kwakiutl Ethnography*. Chicago and London, 1966.

Caamaño, Jacinto. "The Journal of Jacinto Caamaño", ed. by Henry R. Wagner and W.A. Newcombe. *British Columbia Historical Quarterly*, vol. 2, 1938, p. 189 ff and 265 ff.

Cook, Captain James. *The Voyage to the Pacific Ocean*, vol. 2. Condor, 1784.

Drucker, Philip. *Cultures of the North Pacific Coast*. Scranton, Pennsylvania, 1965.

Drucker, Philip. *Indians of the Northwest Coast*. New York, 1955.

Goddard, Pliny Earle. *Indians of the Northwest Coast*. New York, 1972.

Gunther, Erna. *Indian Life on the Northwest Coast of North America: As Seen by the Early Explorers and Fur Traders during the Last Decades of the Eighteenth Century*. Chicago and London, 1972.

Hays, H.R. *Children of the Raven: The Seven Indian Nations of the Northwest Coast*. New York, 1975.

Jenness, Diamond. *The Indians of Canada*. National Museum of Canada, Bulletin 65, Anthropological Series 15. Ottawa, 1967.

Marshall, James Stirrat and Carrie. *Vancouver's Voyage*. Vancouver, 1967.

Macfarlan, Allan A. and Paulette. *Fireside Book of North American Indian Folktales*. Harrisburg, Pennsylvania, 1974.

Indians of the North Pacific Coast: Studies in Selected Topics. Edited and with an Introduction by Tom McFeat. Toronto, 1966.

Menzies, Archibald. *Journal of Vancouver's Voyage*, ed. by C.F. Newcombe. Archives of B.C. Memoir No. 5. Victoria, 1923.

Patterson, E. Palmer II. *The Canadian Indian: A History Since 1500*. Don Mills, Ontario, 1972.

Rogers, E.S. *False Face Society of the Iroquois*. Royal Ontario Museum Pamphlet, Toronto, 1977.

Rogers E.S. *Iroquoians of the Eastern Woodlands*. Royal Ontario Museum Pamphlet, Toronto, 1970.

Wherry, Joseph H. *Indian Masks and Myths of the West*. New York, 1969.

Woodcock, George. *Peoples of the Coast: The Indians of the Pacific Northwest*. Edmonton, 1977.

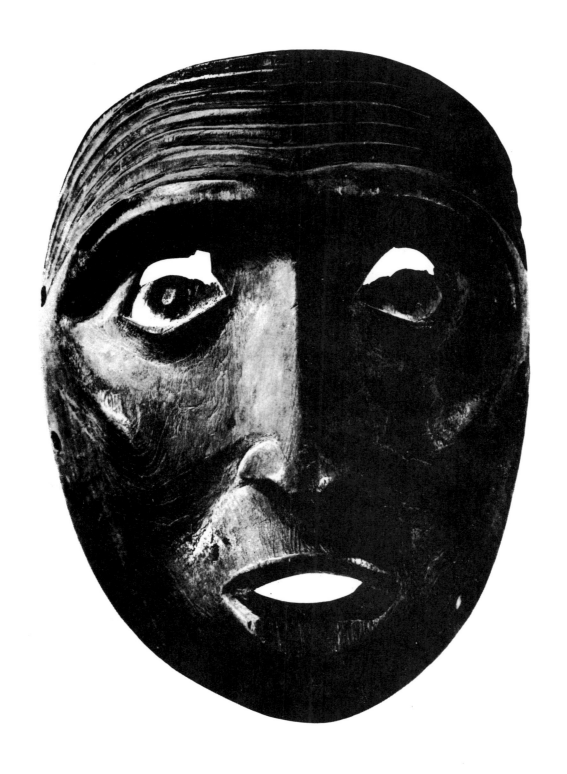

Tribe — Tsimshian — Wooden Mask

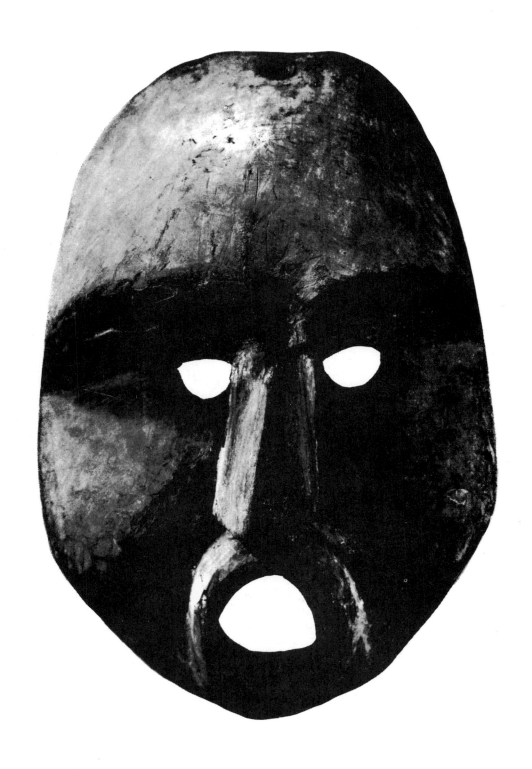

Tribe — Kwakiutl — Wooden Mask

144

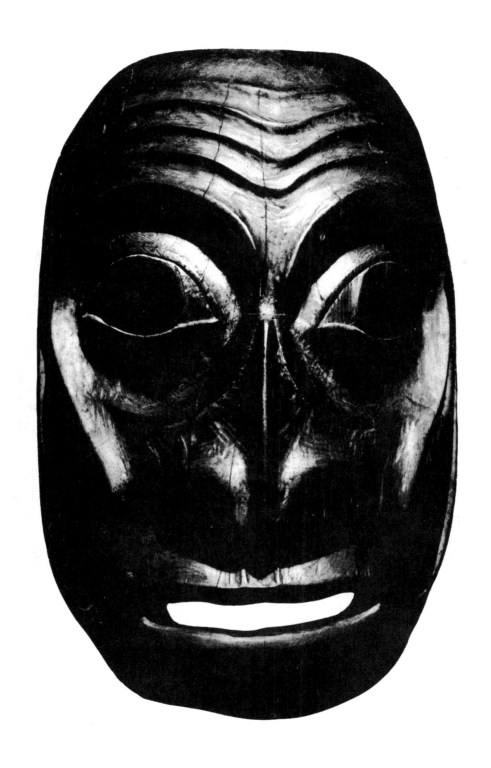

Tribe — Tlingit — Wooden Mask